Research/Practice 04

Research/Practice 04

Trevor Paglen

Adversarially Evolved Hallucinations

Edited by
Anthony Downey

Sternberg Press

Contents

Images: Adversarially Evolved Hallucinations
(2017–ongoing)

All works from the Adversarially Evolved
Hallucinations series, dye sublimation on
aluminium print, dimensions variable.

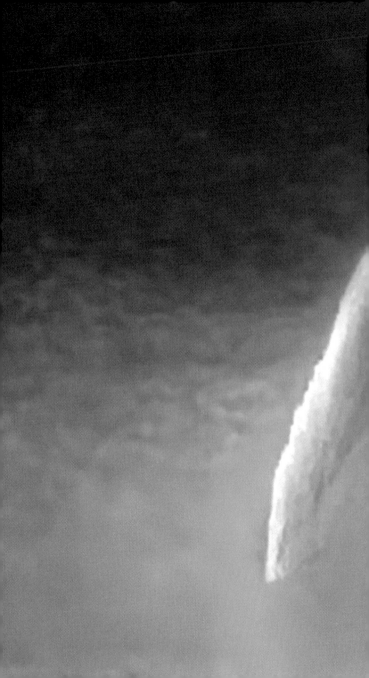

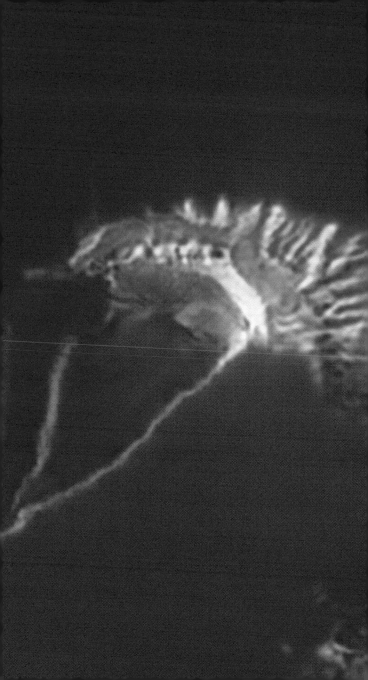

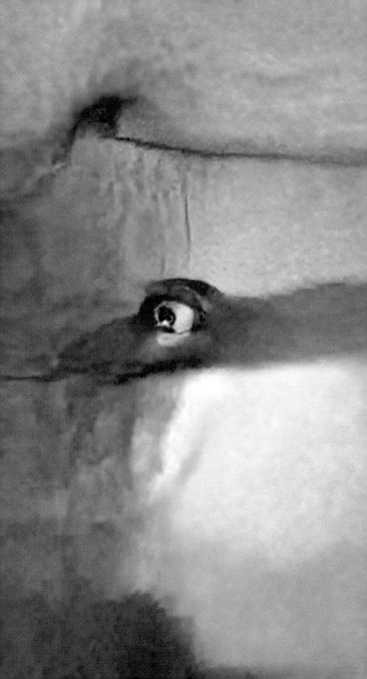

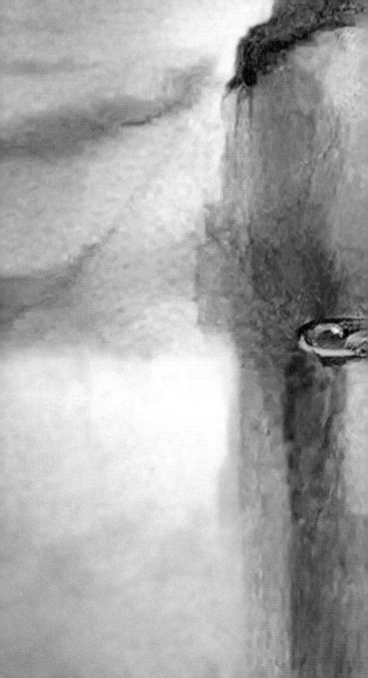

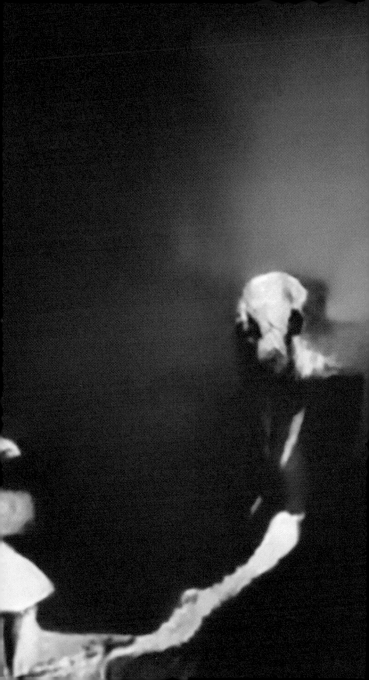

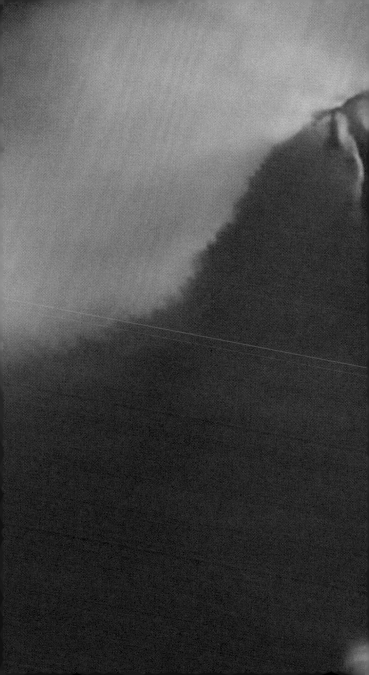

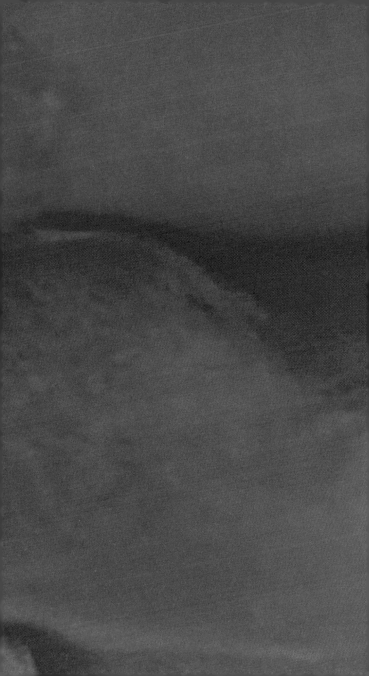

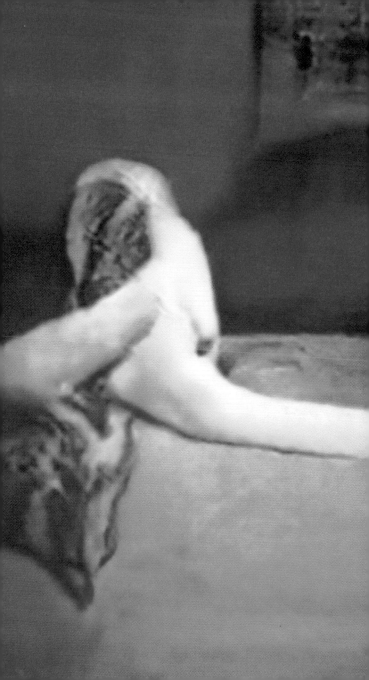

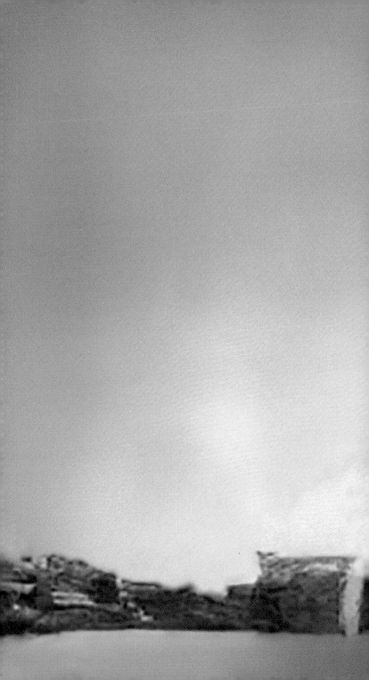

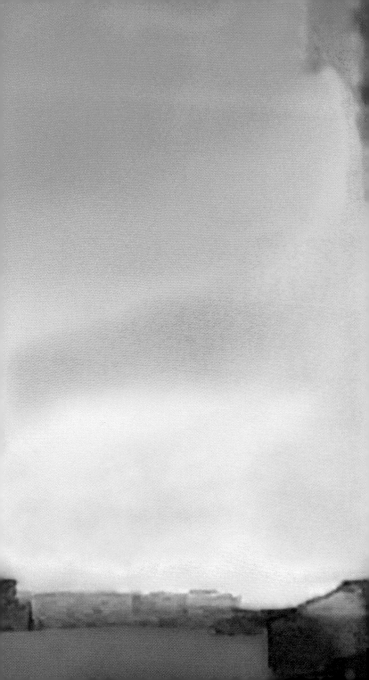

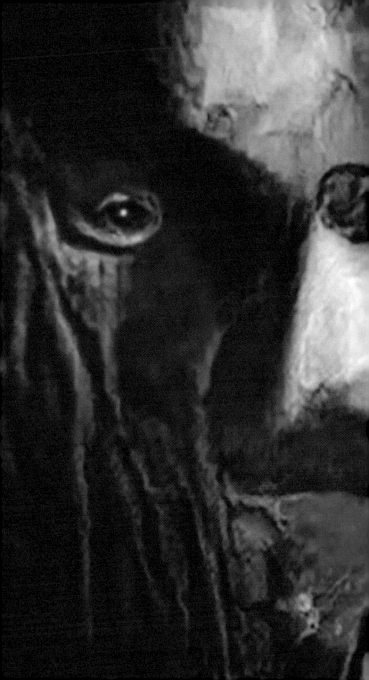

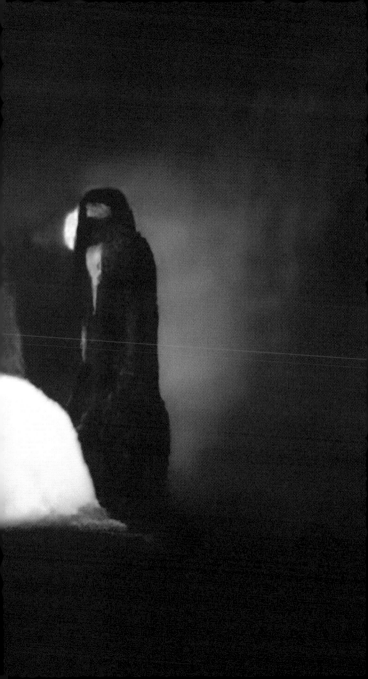

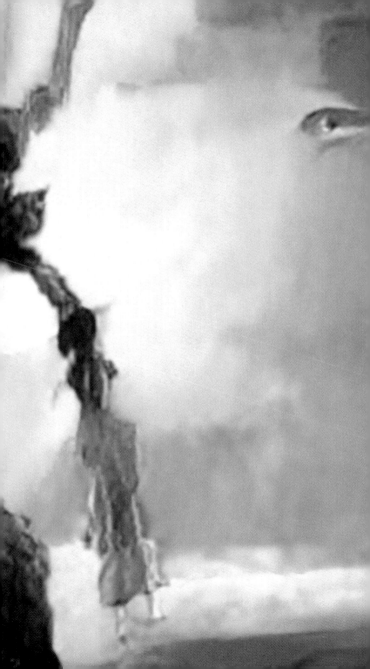

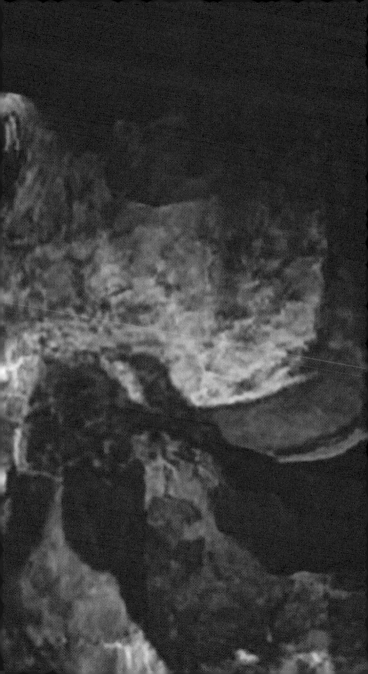

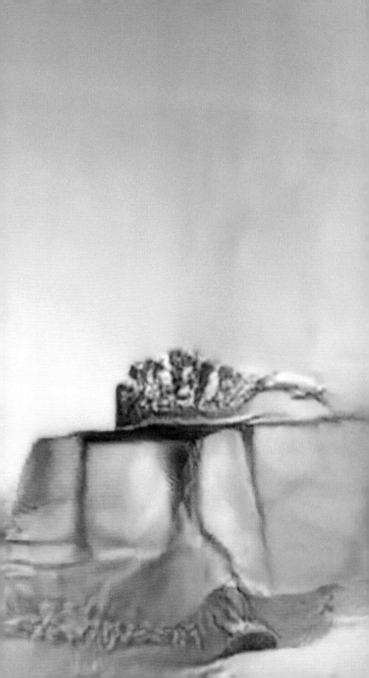

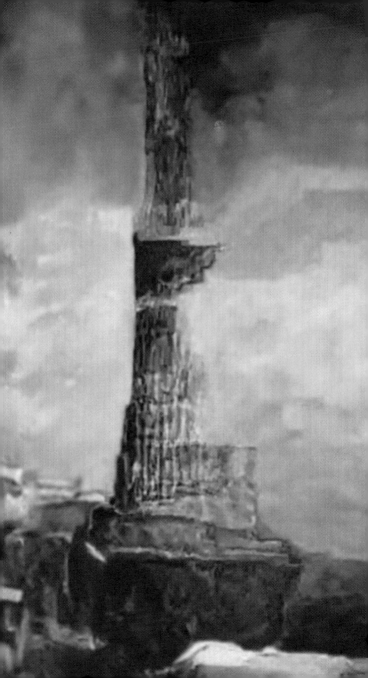

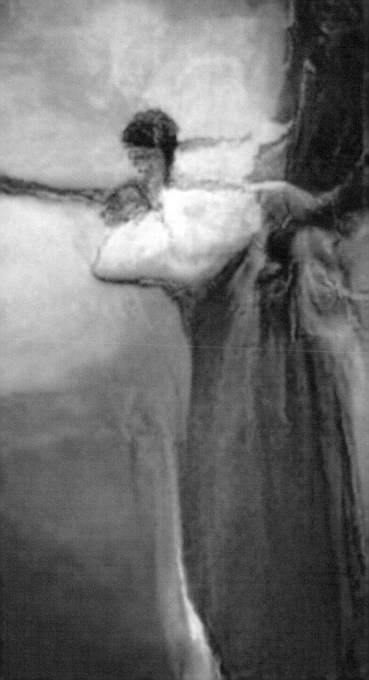

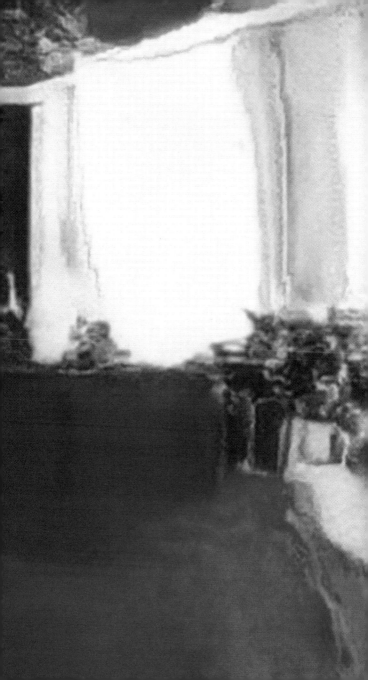

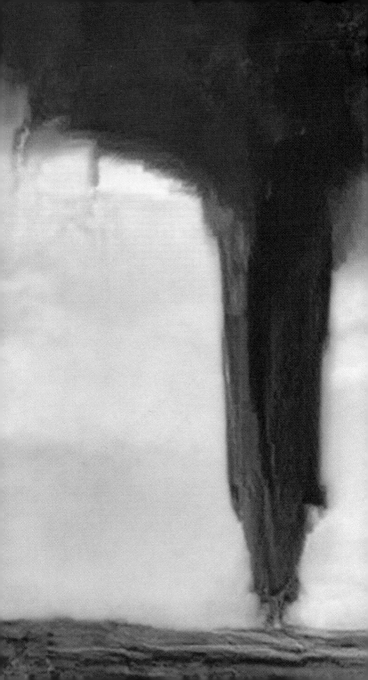

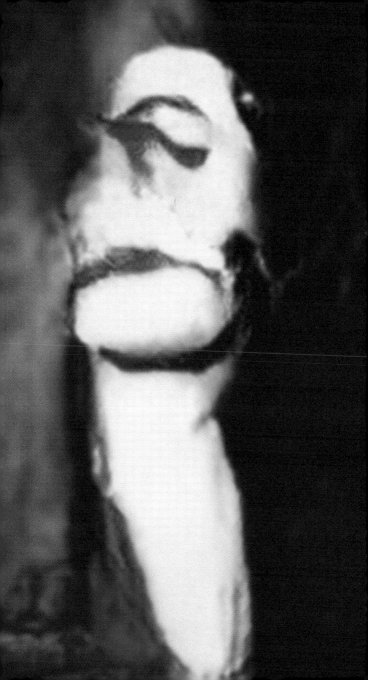

The Return of the Uncanny: Artificial Intelligence and Estranged Futures

Anthony Downey

If an image could be described as baleful, or as having an ominous appearance, *Rainbow* would certainly fit the bill (pp. 22–23). Apart from the toxic-looking "sky," parts of it appear to have mutated into the fiery trace of munitions or, more cryptically, a series of glitches. Suggesting the collation of natural elements and a physical, possibly dead body (corpse/corps), the full title of the work—*Rainbow (Corpus: Omens and Portents)*— further bolsters the overall impression of trepidation and estrangement. Complete with the apparition of deceptively unseeing eyes, this sense of apprehension is equally evident in *Human Eyes (Corpus: The Humans)* where features that resemble—or, more likely, re-assemble—the components of a face mutate into a monstrous visage (pp. 16–17). Appearing both present and yet disconnected, in *Vampire (Corpus: Monsters of Capitalism)* the eyes return but this time with a more cartoonish, disembodied countenance (pp. 24–25). Something is awry in these images which, for the most part, appear to be almost "right" but not quite.

Evoking an *in*human logic, *Rainbow*, alongside other works in Trevor Paglen's Adversarially Evolved Hallucinations series (2017–ongoing), mines the latent spaces of automated image production. Produced by a generative adversarial network (GAN), an artificial intelligence (AI) model that trains itself on a dataset of images in order to recognize, classify, and generate new ones, these unnerving visions suggest an uncanny realm where the familiar and unfamiliar are fused into an embryonic space of image production.[1] Given that AI image-processing models do not experience the world in phenomenological, embodied terms but replicate a once-removed and askew version of it, the peculiar characteristics of images such as *Rainbow* reveal how algorithms computationally generate disquieting allegories of our world.[2] The outcome of algorithmic

The Return of the Uncanny

processes, the works we thereafter encounter offer a view into the "subconscious," often concealed machinations of AI.[3] Throughout this series, a recognizable order of being in the world—be it physical, rational, or otherwise—is dis-placed, or usurped, by a potentially more alien and disturbingly mechanized order. Something comes to light in this spectral realm: an apparition, or a nightmare, that is indebted to the hidden and invariably recursive logic of algorithmic apparatuses.[4]

The *in*human processes at work in AI models of image classification and production prompt a series of questions concerning the degree to which machinic ontologies of perception—powered by algorithmic ratiocinations—are disrupting the ocular-centric field of human vision. How, we could subsequently ask, do machines *see* the world? To this we could add another, perhaps more pertinent, question: How do machinic methods of seeing determine, if not overdetermine, how we perceive and experience the world? Through training neural networks—such as those employed in a GAN—to see, are we priming and instructing ourselves to see like machines? In time, moreover, will *in*human models of seeing supersede human vision in certain areas, not least in the adjacent fields of surveillance and automated models of warfare? To pose such questions is to address a potentially more radical component in prototypes of technologically-induced sight: If AI models of image production replace ocular-centric ways of seeing, do these models have the capacity to further estrange us from the world? It is through addressing these and other questions that we can explore the far-from-abstract impact of delegating the ocular-centric regimen of human perception to a preprogrammed regime of machine vision.[5]

Although presented as an objective "view from nowhere," AI models of image recognition, classification,

and production are designed to identify images according to input (datasets) and instructions (algorithmic weightings). Inasmuch as these apparatuses produce models that are riven with political, racial, and gender-based bias, the hermeneutic ambition underwriting systems of AI image-processing—the impetus to interpret and categorize—can be understood in epistemological terms: they produce meaning and endeavour to *make sense*, in often outlandish but nonetheless narrow terms, of our world.[6] AI can, as a result, reductively encode our perception of the world through machinic frames of reference. It is with these and other concerns in mind that the Adversarially Evolved Hallucinations series examines how machine learning—working from datasets (images)—functions as a computational means to produce knowledge (epistemologies) and, throughout that process, promote AI as a heuristic device: capable, that is, of making sense of, if not predefining, how we perceive the world.

As we will see, AI image-processing techniques perform on varying scales of error, so much so that, as Paglen notes, "the apparent correspondence between what a model is classifying and how it relates its systems of classification to referents 'out there in the world' is not only misleading but hallucinatory."[7] The epistemological *affect* of automated image generation, however hallucinatory the latter may turn out to be, can veer from the merely misleading to the coercive. To fully explore the ramifications of machinic perception, we need to engage in a diagnostic form of reverse engineering: working backwards from the manifest, final iteration of an image such as *Rainbow*, we can explore how the systematic training of a neural network—through the use of datasets—produces images. Through examining *Rainbow*, alongside other works in the series, we can not only better understand how AI models are

systematically trained on datasets, we can also address their epistemological impact—or, more specifically, how they function to simultaneously adumbrate and yet overdetermine our world.[8] When considering the systematic training of a GAN model of image-processing, we likewise need to investigate how neural networks are systemically calibrated by algorithms. It is from within this latent, methodically obscured, space of algorithmic reasoning—involving as it does the machinic calibration of neural networks—that AI produces questionable surrogates and hallucinatory visions of our world.

Through foregrounding the operations involved in compiling, labelling, and algorithmically rationalizing the input data that powers neural networks, Paglen invites us to deconstruct the technological components involved in training a machine to see. This approach makes known, to begin with, how the categorical definitions attributed to datasets imply the potential for epistemological violence—the degree to which, that is to observe, machinic interpretations reduce our world to normative and non-normative, or proscriptive, categories. In undermining the reliability of the image-recognition tasks so readily undertaken by AI, alongside their disputed capacity to fully, if ever, make sense of the complex realities of our world, Adversarially Evolved Hallucinations encourages us to see *through* the systematic, systemic, and epistemological dysfunctions of such apparatuses and question their present-day and, indeed, future impact on our perceptions of the world.

Categorical Dissonance and Epistemological Affect

In order to train a GAN, Paglen established a series of taxonomies with titles that included SPHERES OF PURGATORY, EYE MACHINE, THE INTERPRETATION

OF DREAMS, and OMENS AND PORTENTS. Referencing sources from literature, visual culture, psychoanalysis and folklore, these idiosyncratic taxonomies tended to be both broadly obscure and yet reasonably identifiable. In part, this allusiveness addresses the expansiveness and complexity of knowledge systems, especially as they relate to the world. "Humans," Paglen says, "have all sorts of weird taxonomies that we use to try to makes sense of the world: taxonomies for dreams, tarot cards, historical events, ideas about some things being 'lucky' or 'unlucky,' and even taxonomies of allegories."[9] For Adversarially Evolved Hallucinations, Paglen developed some of his conceptual taxonomies into corpuses that contained datasets.[10] To return to *Rainbow (Corpus: Omens and Portents)*, the corpus OMENS AND PORTENTS consisted of a dataset comprized of individual image categories such as "rainbows," "comets," "eclipses," and "black cats." In these examples, the choice of each image category for a dataset is far from restrictive or regulative. In fact, the cumulative effect of such diverse image categories would appear to contest the overarching restrictions of more functional datasets or, indeed, the supposed practicality and the validity, more generally, of generic classification systems.[11]

Through training an AI model on the OMENS AND PORTENTS corpus/dataset, the GAN began to recognize patterns and features associated with each image category and, in time, classify them. This process of classification is constantly grounded in the original corpus/dataset, so much so that the GAN can only ever classify images that the model has been already trained upon. This entire process of training may appear relatively straightforward if not a tad recursive: you instruct an AI model, using datasets, to classify and produce images *similar* to those it has been trained

upon. However, and depending on the system in use, the process is never totally predictable, nor is it reliable. Among other factors, the training is contingent on biases in the datasets (whereby certain images are over- or under-represented), discrepancies in procedures and, notably, variables in the less-than-transparent adjustments involved in the iterative process of applying algorithmic weightings to input data. The operative logic of a GAN is, in addition, specifically geared towards generating new, as-yet-unseen images, which further renders the entire process subject to a significant degree of computational fortuitousness. Despite the sense of technological determinism often associated with algorithmic devices—the notion that the programmatic identification of patterns in datasets and the application of appropriate weightings to the values associated with such patterns will, in time, give correct predictions—the procedures involved do not *automatically* yield predictable outcomes.

Unlike an ocular-centric field of vision, GANs learn through the statistical analysis of data to capture patterns and features that exist within datasets. These patterns are the basis of the successive predictions, or classifications, that AI models formulate as outputs. Ultimately, these predictions are designed to calculate or recognize *future* patterns. When we look again at *Rainbow*, it is obvious that it is an uncanny vision, or projected hallucination, of a rainbow, inasmuch as it possesses a passing but far-from-unqualified resemblance to one. There is a clear distinction to be had here between machinic and ocular-centric models of classification; however, for the GAN model the image it produced *is* categorically a "rainbow" insofar as it can only ever produce images associated with the dataset upon which the model has been trained.

This latter point remains central to our discussion, as the images we encounter throughout the Adversarially Evolved Hallucinations series have all been apportioned, with high levels of certainty, a definitive category—rainbow, comet, eyes—by a GAN. These frequently bizarre, if not uncanny, classifications convey the degree to which AI image-processing models are commonly, if not ubiquitously, involved in producing, to use Paglen's phrase, a form of "machine realism": "creating a training set involves the categorization and classification, by human operators, of thousands of images. There is an assumption that those categories, alongside the images contained in them, correspond to things out there in the world [...] I refer to these assumptions as 'machine realism.'"[12] The question we are left with is what happens when systems identify, or produce, a "rainbow" that is patently *not* a rainbow, at least not in the conventional sense. Or, similarly, what happens when a generative AI model—such as a GAN—creates, or hallucinates, an image that it announces to be, despite evidence to the contrary, a given thing that is patently *not* the entity in question. We return here to our earlier point: given the omnipresence of AI apparatuses (as evidenced in facial recognition technologies, for example) and their impact on how we see the world, how do we gauge the validity, or effect, of understanding the world through the affordances of machinic models of perception—"machine realism"—and computational frames of reference?

The apparently abstract event of (mis)classification, or hallucination, discloses the deterministic reasoning implied in AI models of image production—this *is* a rainbow; this *is* an apple; this *is* a face—and how it imposes meaning upon the world. The legacy of this imposition, its epistemological *affect*, is far from inconsequential: when deployed in facial recognition

technologies, for instance, such systems assign a classification to a particular object or entity—say, a face—and assigns a name or, more ominously, a level of threat to it. Respectively, there often exists a concomitant tendency to take these categorizations for granted and act accordingly.[13] In programmatically presenting the world through the computational inferences of neural networks, AI models of image-processing would appear to be increasingly programming us to accept machinic conjectures as the "truth" of our world rather than, as they in fact are, conditional projections and probabilistic predictions.

Generative AI models, such as GANs, are statistical systems of rationalization that classify, with varying levels of efficacy, images and other data. Despite the inherently biased nature of machine learning (not to mention the tendency to hallucinate), we increasingly appear to be delegating responsibility for, and our responsiveness towards, the epistemological impact and *affect* of such technologies.[14] Through the statistical analysis of patterns, conducted in order to calculate or recognize future patterns, mechanistic predictions of people's identities, shopping preferences, credit ratings, career prospects, health status, political affiliations, and supposed susceptibility to radicalization, become the norm rather than the exception. The innately machinic process of classifying an image can, in turn, provoke or bring about an action, or event, wherein which the calculus of an algorithmic "aperture" is procedurally focused on "distill[ing] something for action."[15] The predictive inclination of AI technologies, their projective functioning and distillation of realities into precepts for action (which are usually disciplinary in nature), become self-fulfilling and unaccountable—if not unfathomable—principles in the determination of a subject's suitability across

a range of situations, positions, and tasks. We confront here the implications involved in the machinic calculation of normative and—perhaps more troublingly for those caught in the capacious ambit of automated models of image-processing and classification—non-normative activities, behaviors and subjectivities.

If *Rainbow* is a machinic analogy of a rainbow, summoned forth by algorithmic reasoning, how then do we understand the processes through which neural networks arrive at such images? How, that is to ask, do we think from *within* these systems rather than merely reflect upon their potential impact? To these inquiries, we could ask what happens when image-processing models are computationally deluded in their projections. Instances of hallucination in neural networks are, to be clear, neither rare nor unaccounted for; on the contrary, they are indelibly associated with a "counterintuitive and unexpected form of brittleness [that is] replicated across most deep neural networks currently used for object recognition."[16] We could note here a particularly germane study involving an InceptionV3 image classifier that consistently classified an image of a turtle as a "rifle."[17] The authors of the paper noted that as "an example of an adversarial object constructed using our approach," a 3D-printed turtle was "consistently classified as a rifle (a target class that was selected at random) by an ImageNet classifier."[18] This occasionally dry technical detail reveals a profound reality that remains intrinsic to the neural networks and deep-learning models involved in training machines to see: they are not only systematically prone to category errors, they are also systemically susceptible to inventing (or hallucinating) objects that do not exist.[19]

The Return of the Uncanny

Image-processing models can also add interpretive context that is grievously biased, not least when we consider the widespread use of such apparatuses in policing. In an investigation undertaken by AlgorithmWatch in 2020, to take a particularly apt example of interpretive and epistemological *affect*, it was demonstrated that Google's Vision Cloud labelled "an image of a dark-skinned individual holding a thermometer [as a] 'gun' while a similar image with a light-skinned individual was labeled [as an] 'electronic device.'" Even though Google, once alerted to the bias, fixed it, the investigation by AlgorithmWatch went on to conclude that "the problem is likely much broader."[20]

We will return to the subject of "brittleness" below but, for now, I want to observe that the inclination to hallucinate or misclassify a specific class of image is not a one-off fault or glitch in the system; rather, the event of hallucination is central to the functioning of neural networks and their generative modelling of the world. Established through the statistical rationalization of data, AI produces hermeneutic structures that are often the outcome of distortion—hallucination—and opaque methods of algorithmic calibration.[21] It is this element of distortion in the latent space of machine learning that Paglen activates when he explores, in conjunction with his inquiry into the systematic training of a neural network, the systemic, iterative contexts of machine learning. In focusing on the hallucinatory, latent, and systemic domain of algorithmic computation, we can see how conventional, and increasingly instrumentalized, applications of machine learning systems can be provisionally uncoupled from their utilitarian applications.

Research/Practice: Trevor Paglen

Machinic Hallucinations: How to See *through* Generative Adversarial Networks

Consisting of interconnected nodes or neurons, neural networks employ layers that mimic the function of biological neurons in the human brain. This is true of a GAN system where there is a layer for input data, one or more hidden layers where algorithmic convolutions occur, and an output layer for prediction or image classification. There are two operative neural networks in a GAN, both working in tangent with one another. Obstinate competition in the task of image classification (the responsibility of the discriminator) and image production (the function of the generator), ensures that these neural networks are, as the name suggests, profoundly adversarial.[22] Although mindful not to anthropomorphize neural networks (inasmuch as they are, technically, machinic methods of computation), we could consider the relationship between the discriminator and the generator as similar to that which exists between, respectively, a law-maker and a law-breaker.[23] The discriminator (law-maker) is consistently preoccupied, in this reciprocal alliance, with discerning the difference between real images and "fake" images, whereas the generator (law-breaker) is absorbed with trying to "fool" the discriminator with synthetic, as-yet-unseen images.

Over the course of this competitive relationship, the discriminator is effectively encouraging (training) the generator to deceive it: the more convincing the generated image, the more likelihood it will be ascribed a specific class by the discriminator. A GAN can be therefore understood, in part, as an autodidactic, if not autopoetic, mechanism: it teaches itself to learn and make distinctions.[24] This apparently dexterous process, based on an iterative procedure that involves looped

models of feedback, has nevertheless proved to be a fertile ground for the generation of delusions—or hallucinations—and figments of the algorithmic "imagination." It is from within this occluded zone (often referred to as a "black box") that we can further locate the evolving imagistic logic that is central to the Adversarially Evolved Hallucinations series and how images such as *Rainbow* encourage the viewer to see *through* neural networks.

Although there are differences between how a GAN and other neural networks operate, the methods of rendering digital images or video data ready for processing is similar across most image-processing and image-classifying tasks. Images, digitally rendered and compiled into datasets, are commonly but not exclusively submitted in the form of a legible vector or raster-based model of representation, the latter being a rectangular matrix or grid of square pixels. When magnified, in the case of a raster-based image, a pixel appears as a square of sorts—or, more precisely, a "blob."[25] Image-processing algorithms, used to train neural networks to see, assign a numerical value to these colored blobs. This value is based on intensities of colors, which are often represented by three-or four-color models such as red, green, and blue (RGB), or cyan, magenta, yellow, and black (CMYK). The numeric values attached to these intensities of color (or blobs/pixels) are thereafter weighted through the application of algorithms. Each of these weights, or biases, are repeatedly adjusted and attuned until a desired conclusion is realized; until, that is, the neural network classifies a certain image as being a "real" or identifiable image.

This is, in albeit simple terms, the basis of machine vision: images, rendered as pixels, are assigned a

numerical intensity value that can be subsequently weighted by algorithms or, as is often the case, groups of algorithms. These weights, when calculated alongside other weights, can produce an estimation (output) as to what the input image represents. When a neural network has been calibrated to recognize and identify known images (inputs), images can be uploaded (again as numeric code) to train (test) its capacity for predicting a class of images. To this end, a neural network does not see an image as such; rather, it scans a series of numerical values that add up to, or stand in for, an image. Neural networks are trained, in sum, not on an image but on images converted into numbers—and it is from within this multidimensional, latent space of numeric manipulation that they begin to hallucinate.

While both the discriminator and the generator are engaged a zero-sum game of optimization, the overarching purpose of the former is to correctly classify both real and generated (fake or synthetic) data.[26] In the latent spaces of computation, where the generator seeks to "fool" the discriminator, the counterfeited images that pass muster assume the distinction of being categorically "real." This is regardless of their frequently bizarre or, as we see in *Rainbow*, estranged and uncanny appearance. To fully appreciate how this occurs, we need to stress that in the initial stage of training the generator produces random noise that is relayed to the discriminator. The discriminator subsequently supplies the generator with automated feedback as to how closely the generated data resembles the images that the model was trained upon. To the machine eye, which is in a recurrent state of algorithmic calibration and recalibration, some images will look more "real," as opposed to fake or synthetic, than others.[27] To begin with, this resemblance might be as low as 0.00001%. However, through multiple iterations of the process

The Return of the Uncanny

(and allowing for the vast computational power that can be now brought to bear upon data inputs), this figure will eventually shorten.

The ultimate goal in a GAN is to therefore reach a stage where the generated samples are indistinguishable from the real samples. There exists, in consequence, a distinctly delusional basis to the entire generative process involved in training a GAN: the generation of synthetic images is designed to delude the sentinel-like structure of the discriminator. It is these so-called "fooling" images, an image type that the generator has produced to deceive the discriminator, that eventually become indistinguishable from real data. The sheer power of recursion, the looped subjection of data to countless iterations and weightings, seems to invite a spiralling sense of mechanical delirium, or hallucination. It is in this mise en abyme, where images mutate and transmogrify, that we can see how the brute "force[s] of computation" can give way to computational delusions.[28]

When we look again at the images in Adversarially Evolved Hallucinations, which often appear to be in a state of perpetual evolution or collapse, we can recognize certain components in them, including shapes, edges, and forms. These subcomponents are called "primitives" (pp. 140–55) and Paglen understands them as being akin to a brushstroke or a pencil mark, whereby each of the primitives represents a basic shape or line that could constitute a bigger picture: "a banana is likely to have two arcs ranging from the top to the bottom of the fruit; it could have yellow color gradients, some brown spots, a stem at the bottom, and so on. Each of these subcomponents will be represented in the primitives of the image—arcs, nonparallel lines, brown spots, stems, and so on."[29] In a neural network, primitives, the subcomponents

Research/Practice: Trevor Paglen

of an image, exist in the latent space of the AI model and provide the amorphous foundations for machine learning to produce more and more complex images. The arcs, gradients, lines, colors, shapes, and other subcomponents will, over time and through iterative looped procedures, evolve into manifest images. Crucially, it is the intervention into the evolutionary stage of image production that reveals the systemic operative logic involved in algorithmically calibrating a neural network. As Paglen notes, it is at this stage of image evolution that he can instruct the neural network to "generate an image of 'neuron 7382,' or any other place (neuron) in the latent space. The generator then evolves an image in the direction of criteria dictated by the specificities of what is in the latent space."[30]

In this scenario, "neuron 7382" has been produced by the generator (law-breaker/counterfeiter) and, as Paglen acknowledges, he can intervene to instruct it to develop this abstract image or "neuron" toward ever more fantastical ends. Through intervening into the systemic process involved in training a neural network, Paglen can effectively harness the computational forces to develop—from a given point in the latent space of the iterative process—a given output (image), however bizarre, that can nevertheless "fool" the discriminator into believing it is a class of image that the model has been trained upon. In this context, *Rainbow* is indeed an image of a rainbow insofar as its training data (input) has been weighted to the degree that a synthetic image can pass for real, at least in the eyes of a GAN.

Insofar as image-processing systems do not return exact replicas or accurate classifications of the world, they can hallucinate realities into being.[31] It is this predisposition that Paglen heightens when he intervenes into the systemic, latent sphere of algorithmic

reasoning. It is here, where images return to us in uncanny variations on a theme, that the common applications of image-processing algorithms can be critically disconnected from their utilitarian function and revealed for what they are: statistical approximations and mechanical allegories of reality. Given the relative opacity in the systemic functioning of neural networks, the abiding concern is that the algorithmic rationalization of data—which employs a range of weights and biases to support machine learning processes to better recognize images—can pick up on patterns in data that simply do not exist except, that is, within the preserve of a computational illusion or in the pathologies of a mechanically induced delirium.

From the outset of our discussion about GANs it is apparent that the seemingly delirious resolve to produce ever more accurate ("real") and yet "counterfeit" images can and does give rise to hallucinatory realms. This tenaciousness, an integral element in the operative logic of a GAN, is crucial and yet it divulges a seemingly pathological impulse toward generating ever more fantastical, if not phantasmal, images. Revealing inherent forms of "brittleness," these flashes of computational delirium contradict the frequently inflated claims made in relation to the effectiveness of neural networks in image-classification tasks. We return here to the uncanny *affect* of such systems, and the degree to which, regardless of their intrinsic failings, they are widely used to produce paradigms— or epistemological frameworks—for understanding the world. We could note here, in the context of datasets, AI, and the deterministic logic of such apparatuses, Taina Bucher's insights into how the algorithms that render neural networks viable are resolutely "political

in the sense that they help to make the world appear in certain ways rather than others. Speaking of algorithmic politics in this sense, then, refers to the idea that realities are never given but *brought into being and actualized in and through algorithmic systems.*"[32] Algorithmically defined outputs, systemically calibrated from input data and optimized—modulated—by weightings, are always already political inasmuch as they summon forth computational, routinely normative, models of our world.

Notwithstanding the misplaced degree of confidence in AI, alongside the proven shortcomings, or should that be excesses, of neural networks, computational projections are frequently presented as categorically deterministic—this *is* a rainbow; this *is* a face; this *is* a threat—rather than, as they are in reality, approximate estimates of a given reality based on statistical inferences garnered from patterns in a dataset. Given the accumulative and ascendant influence of AI on our lives and how we live, there is a strong argument here for developing research methods—such as those deployed throughout the Adversarially Evolved Hallucinations series—that are designed to encourage a critical range of thinking from *within* these structures rather than merely reflecting upon their impact. Through developing such research, we can ensure that the systematic methods (involved in labelling and inputting data, for example) and systemic (latent and algorithmic) spaces of computation are more readily understood for what they actually are: statistical calculations of probability that seek to define our realities and, in so doing, further estrange us from the world and our futures.

1 The concept of the uncanny as an unhomely or frightening apparition is key to Sigmund Freud's seminal essay "The Uncanny," first published in 1919. It is here that Freud observes how the German word *unheimlich* is "obviously the opposite of '*heimlich*' [homely], '*heimisch*' [native]" and therefore the inverse of the familiar or not known. Sigmund Freud, "The Uncanny," in *Art and Literature*, vol. 14, The Pelican Freud Library (London: Penguin Books, 1988), 341.

2 There are numerous critiques of AI in relation to its hermetic, non-embodied prefigurations of the world. Among the more enduring are Hubert Dreyfus's 1965 paper for the RAND corporation, "Alchemy and AI," and his later volume *What Computers Can't Do: The Limits of Artificial Reason* (New York: Harper and Row, 1979). The question of the relationship between mind, knowing, experience, and embodiment is, needless to say, a perennial philosophical concern, and the question of disembodied intelligence is but one issue raised in relation to the proficiencies of machine learning.

3 In "The Uncanny," Freud describes an event where, having been confronted by his own reflection in a mirror and the prospect of someone mistakenly entering his private train compartment, he recalls not only being aghast at the sight of this "intruder" but repulsed by the "vestigial trace of the archaic reaction which feels the 'double' to be something uncanny." For Freud, the effect, or *affect*, of doubling is consistent with a visual specter—a phantasmal presence that is accelerated by processes of mechanization and automation. Freud, "The Uncanny," 371.

4 Quoting German philosopher F. W. J. Schelling's *Philosophy of Mythology* (1857), Freud notes that the uncanny can be understood as "the name for everything that ought to have remained (...) secret and hidden but has come to light." Freud, "The Uncanny," 345.

5 The process of delegating sight and perception to machines (cameras, in particular) was addressed by, among others, Vilém Flusser (1920–1991). Considering how the concept of human agency was being increasingly regulated, Flusser argued that the "technical image"—which he viewed as a nascent regime of image production—was effectively produced by apparatuses rather than humans. The outcome of sequenced, recursive computations, the technical image heralded the demise of human-centric activities in models of image production. Through the technical image, the "original terms *human* and *apparatus* are reversed, and human beings operate as a function of the apparatus." Vilém Flusser, *Into the Universe of Technical Images* (1985; repr., Minneapolis, MN: University of Minnesota Press, 2011), 74. Emphasis in original.

6 For an in-depth discussion of how AI image-processing models, alongside the ImageNet database, reify political, racial, and gender-based bias, see "Algorithmic Anxieties: Trevor Paglen in conversation with Anthony Downey," *Digital War* 1 (2020): 18–28. http://www.anthonydowney.com/wp-content/uploads/2023/03/00_Algorithmic-Anxieties_Paglen-Downey-OnlinePDF-copy.pdf.

7 See page 122.

8 I am drawing here upon the Latin root of the term "adumbrate"—namely, *umbra* or shadow—and the way in which it describes the event of *giving an outline* or form to an object, through foreshadowing, and also the fact of *casting a shadow upon it*.

9 See page 120.

10 Throughout the Adversarially Evolved Hallucinations series, Paglen used "corpus" as another term for dataset, the latter being a collection of image categories. Capitalized

throughout for the sake of clarity, the corpuses/datasets that make up the individual taxonomies for the series include OMENS AND PORTENTS; THE INTERPRETATION OF DREAMS; AMERICAN PREDATORS; EYE MACHINE; THE AFTERMATH OF THE FIRST SMART WAR; MONSTERS OF CAPITALISM; THE HUMANS; THINGS THAT EXIST NEGATIVELY; FROM THE DEPTHS; KNIGHT, DEATH, AND THE DEVIL; SPHERES OF HEAVEN; SPHERES OF PURGATORY; and SPHERES OF HELL.

11 According to Paglen, his choice of image categories for each dataset/taxonomy are a direct critique of the "Linnaean taxonomies used in machine learning models" (See p. 120). In his discerning analysis of Adversarially Evolved Hallucinations, Luke Skrebowksi has proposed that the artist "deliberately scrambles taxonomic categories and in so doing denaturalizes and destabilizes the notion of taxonomy as a framework within Enlightenment modernity as carried across into computer science and computer vision." Luke Skrebowski, "Trevor Paglen's Adversarially Evolved Hallucinations: Computer Vision, GAN Photomontage, and the Displacement of Photography's Liquid Intelligence," in Marcel Finke and Kassandra Nakas, eds., *Materials in Motion* (Berlin: Dietrich Reimer Verlag, 2022), 145–64 (151).

12 See page 118.

13 For an engaging discussion of Adversarially Evolved Hallucinations and facial recognition technologies, see Lila Lee-Morrison, *Portraits of Automated Facial Recognition: On Machinic Ways of Seeing the Face* (Bielefeld: transcript Verlag, 2019), 159–75.

14 Observing the automation of perception through the use of artificial neural networks, Matteo Pasquinelli and Vladan Joler have argued that AI

models of image-processing represents a new "cultural technique": "What a neural network computes is not an exact pattern but the statistical distribution of a pattern. Just scraping the surface of the anthropomorphic marketing of AI, one finds another technical and cultural object that needs examination: the statistical model. What is the statistical model in machine learning? How is it calculated? What is the relationship between a statistical model and human cognition?" See Matteo Pasquinelli and Vladan Joler, "The Nooscope Manifested: AI as Instrument of Knowledge Extractivism," *AI & Society* 36 (2020): 1263–80.

15 Louise Amoore, *Cloud Ethics: Algorithms and the Attributes of Ourselves and Others* (Durham, NC: Duke University Press, 2020), 16.

16 Paul Scharre, *Army of None: Autonomous Weapons and the Future of War* (New York: W. W. Norton & Company, 2018), 182. In one particularly germane example of this "brittleness," a state-of-the-art image-recognition neural network was shown images that to the human eye resembled nothing more than "white noise" or static, but were nonetheless identified as an "armadillo" and a "cheetah" with a 99.6 percent certainty by the AI image-processing model. See Scharre, 180–88.

17 The Inceptionv3 image-identification model is a pretrained convolutional neural network, or CNN, that is forty-eight layers deep. Although it operates differently from a GAN, both use neural networks that display a recurrent "brittleness" that regularly generates levels of hallucination.

18 Anish Athalye et al., "Synthesizing Robust Adversarial Examples" (paper, Proceedings of the 35th International Conference on Machine Learning, Stockholm, Sweden, June 7, 2018), 19. https://arxiv.org/pdf/1707.07397.pdf.

19 The issue of hallucinations in AI models such as ChatGPT has become a key source of concern for both programmers and users alike. Generative pre-trained transformers (GPTs) are instructed on large language models (LLMs), which use neural networks—specifically deep neural networks—to predict and project outcomes (in this case, text-based outputs). Although an AI system such as ChatGPT is understood to have hallucinated when it produces inaccurate information or specious answers, such outputs can appear all too plausible.

20 Nicolas Kayser-Bril, "Google Apologizes after Its Vision AI Produced Racist Results," *Algorithm Watch* (April 7, 2020). https://algorithmwatch .org/en/google-vision-racism/.

21 Dan McQuillan has argued that the statistical rationalization of data reveals a system susceptible to generating probabilistic simulations (forecasts) based on the transformation (modulation) of data: "Let's say we are dealing with a video: each pixel in a frame is represented by a value for red, green, and blue and the video is really a stack of these frames. So, when representing the video as numbers, the input into the algorithm is a huge, multidimensional block of data. As the input is passed through a deep learning network, the successive layers enact statistically driven distortions and transformations of the data, as the model tries to distil the latent information into output predictions." Dan McQuillan, *Resisting AI: An Anti-fascist Approach to Artificial Intelligence* (Bristol: Bristol University Press, 2022), 19.

22 Ian J. Goodfellow et al., "Generative Adversarial Networks," *Communications of the ACM* 63, vol. 11 (November 2020): 139–44.

23 Writing in the 2014 paper that announced the discovery of GANs,

the authors outlined this adversarial relationship in precisely such terms: "The generative model [generator] can be thought of as analogous to a team of counterfeiters, trying to produce fake currency and use it without detection, while the discriminative model [discriminator] is analogous to the police, trying to detect the counterfeit currency. Competition in this game drives both teams to improve their methods until the counterfeits are indistinguishable from the genuine articles." See Goodfellow et al, "Generative Adversarial Networks," 1–2.

24 *Autopoiesis* is a term used to describe a self-sustaining and self-replicating system that can produce and organize its own components, allowing it to subsist and sustainably adapt to its environment. The concept was introduced by biologists Humberto Maturana and Francisco Varela to explain the self-maintenance and self-reproduction observed in living organisms. Their theory was subsequently adopted in the context of cybernetics and, in turn, the development of AI and machine learning. See Humberto Maturana and Francisco Varela, *Autopoiesis and Cognition: The Realization of the Living*, Boston Studies in the Philosophy of Science 42 (1972; repr., Boston: D. Reidel Publishing, 1980).

25 For a fuller discussion of what a pixel looks like, see Alvy Ray Smith, *A Biography of the Pixel* (Cambridge, MA: MIT Press, 2021). Smith affirms that pixels are not square as such but rather more "blob-like" and have no shape until they are "spread" by a so-called pixel spreader—the latter being a formal filtering mode of reconstructing waves of light for the purpose of computational display.

26 Neural networks are, as one paper would have it, easy to fool insofar as "it is easy to produce images that are

completely unrecognizable to humans, but that state-of-the-art DNNs [deep neural networks] believe to be recognizable objects with over 99% confidence (e.g. labeling with certainty that TV static is a motorcycle)." See Anh Nguyen, Jason Yosinski, and Jeff Clune, "Deep Neural Networks are Easily Fooled: High Confidence Predictions for Unrecognizable Images" (paper, Conference on Computer Vision and Pattern Recognition, 2015), 427–36.

27 It is common in contemporary models of machine learning and computer vision for multiple algorithms to be used, and the combination is usually defined by the task in hand. The event of machinic seeing could involve the use of filtering algorithms (that smooth or sharpen images), edge-detection algorithms (for the identification of edges and boundaries), color-processing algorithms (for adjusting color balance, saturation, and contrast), or segmentation algorithms (for the division of an image into zones based on pixel intensity or for grouping adjacent pixels with comparable properties).

28 For an insightful account of algorithmic violence as a "force of computation," see Rocco Bellanova et al., "Toward a Critique of Algorithmic Violence," *International Political Sociology* 15, vol. 1 (March 2021): 123.

29 See page 125.

30 See page 127.

31 Somewhat worryingly, as Scharre has noted, this "bizarre [vulnerability] that humans lack" raises considerable doubts about the "wisdom of using the current class of visual-object-recognition AIs for military applications." Scharre, *Army of None*, 182. For a fuller discussion of these vulnerabilities in computer vision and the implications for aerial warfare, drone technologies, and lethal autonomous weapon systems, see Anthony Downey, "Algorithmic Predictions and Pre-emptive Violence: Artificial Intelligence and the Future of Unmanned Aerial Systems," *Digital War* 5, vols. 1–2 (2024). https://link.springer.com/article/10.1057/s42984-023-00068-7.

32 Taina Bucher, *If … Then: Algorithmic Power and Politics* (Oxford: Oxford University Press, 2018), 3. Emphasis added.

The Return of the Uncanny

Images: Datasets

Used to train, test, and evaluate image-processing
models, datasets are the raw material of machine
learning and generative adversarial networks (GANs).
In the Adversarially Evolved Hallucinations series,
each dataset contains multiple image categories.
For example, the OMENS AND PORTENTS dataset
includes the image categories "rainbows," "comets,"
"eclipses," and "black cats." On the following pages
are samples of the image categories that were included
in the datasets used to produce the final images in the
series. The image categories are, in order: "comets,"
"false teeth," "Venus flytrap," "the great hall," "the
highway of death," "a man," "octopus," "a pale and
puffy face," "a war without soldiers," "a prison without
guards," "the Tower of Babel," and "vampire." The
quality of certain images in these datasets varies, with
some having a more pixelated appearance than others.
This is critical to the process involved in training a GAN,
insofar as image-processing algorithms essentially
assign discrete numerical values to pixels based on
intensities of colors.

Note: Throughout the Adversarially Evolved
Hallucinations series, Paglen uses "corpus" as another
term for "dataset."

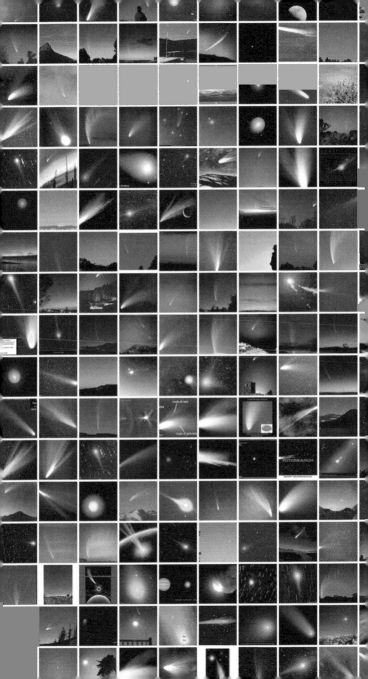

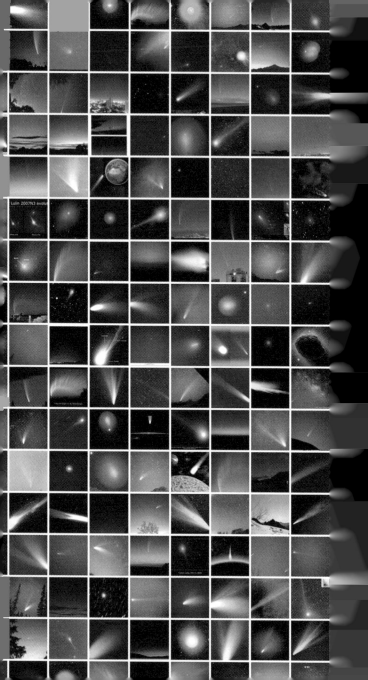

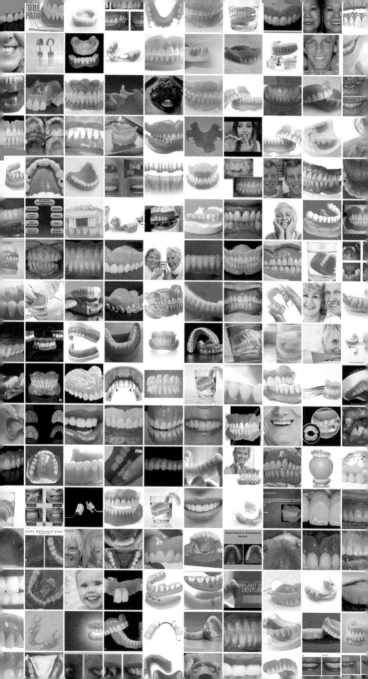

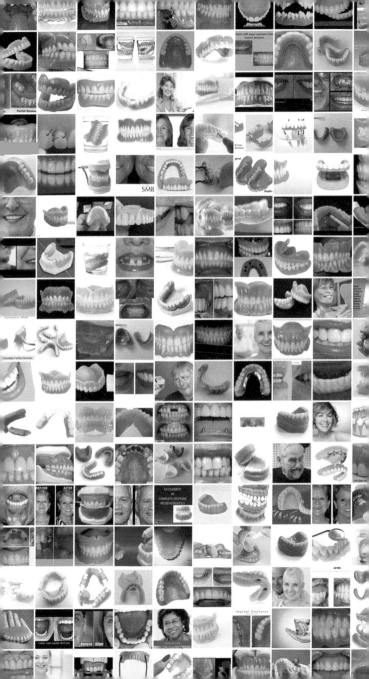

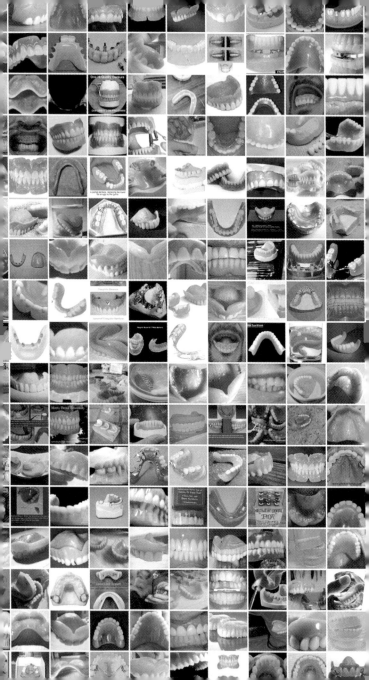

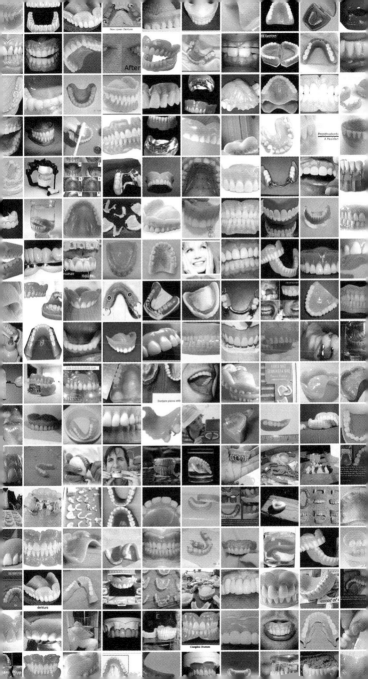

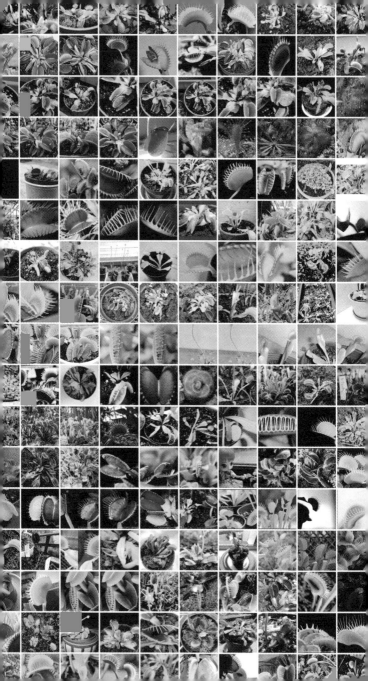

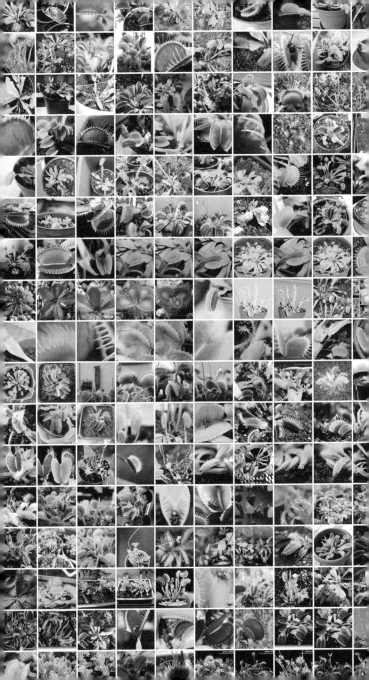

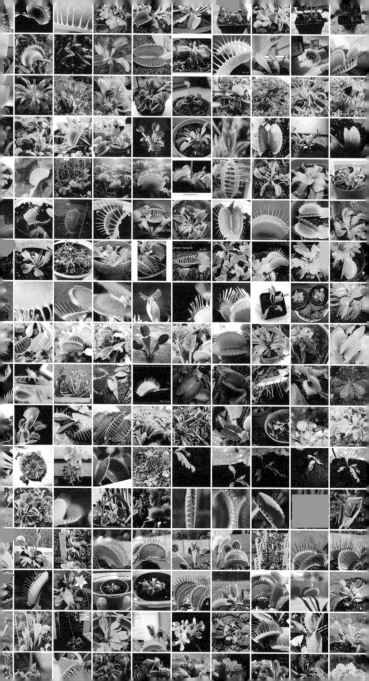

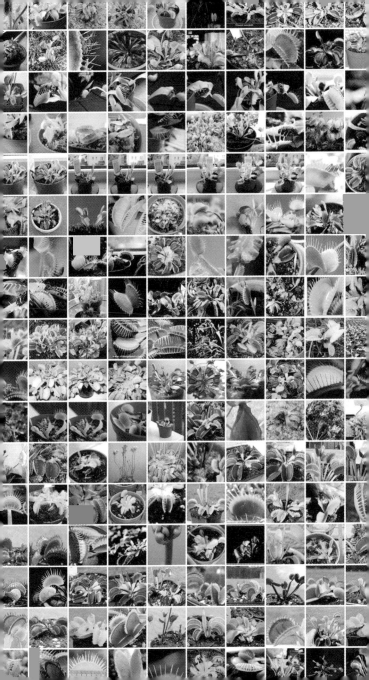

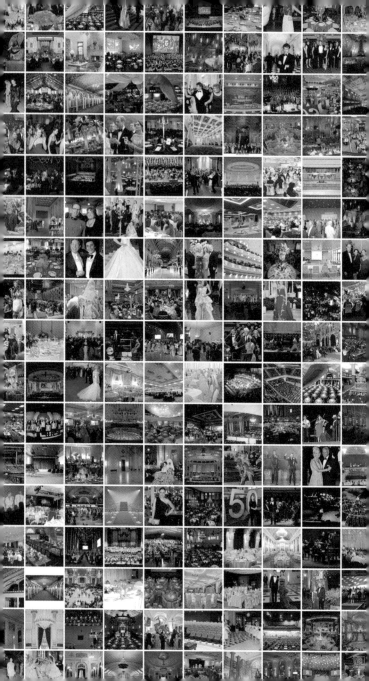

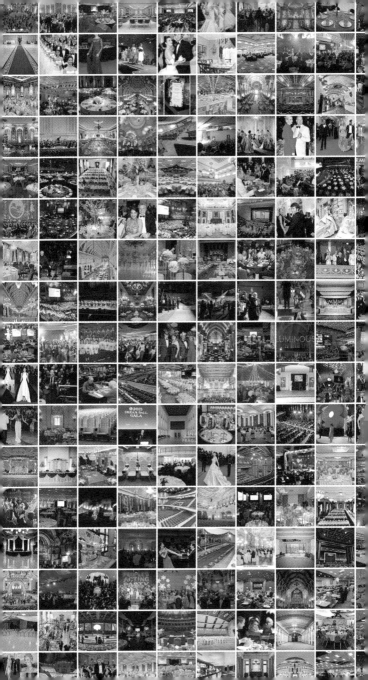

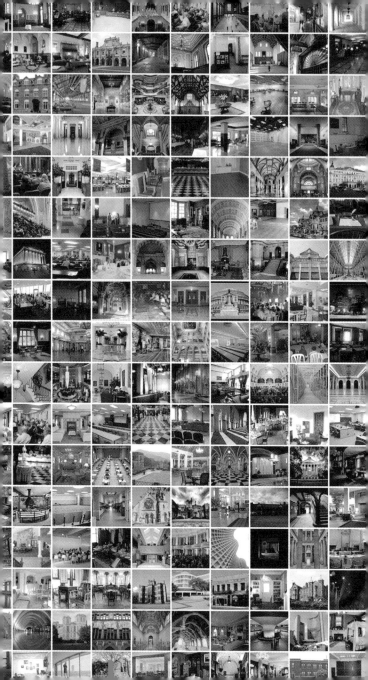

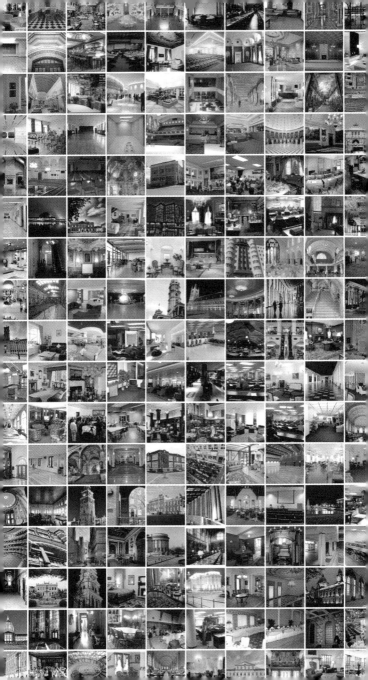

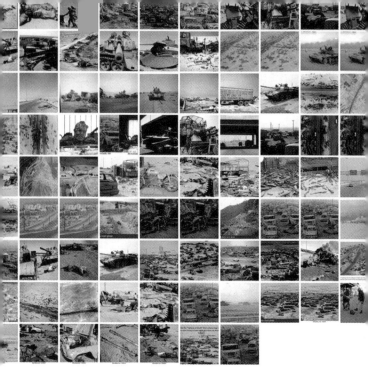

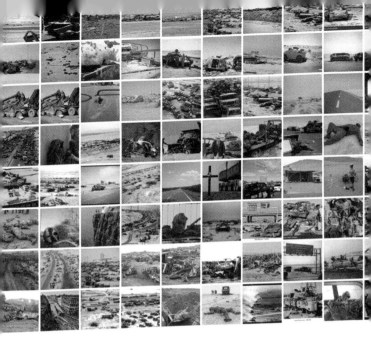

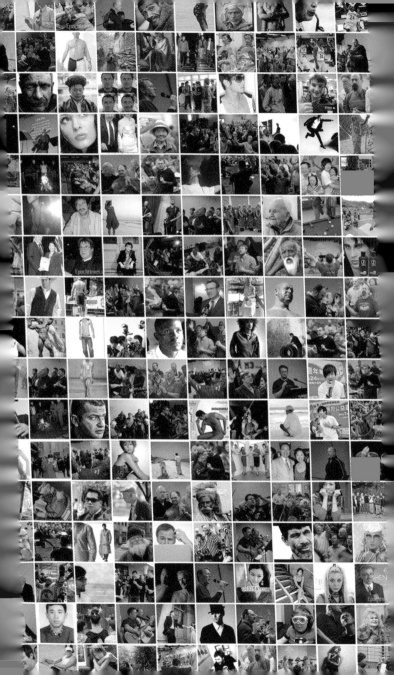

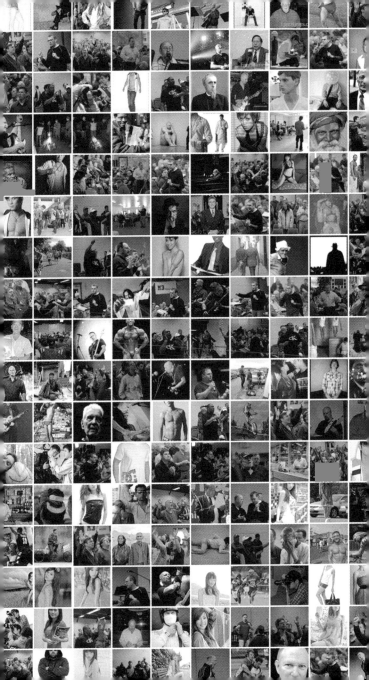

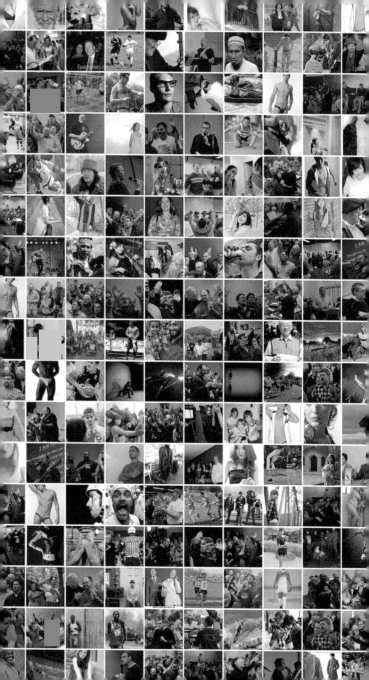

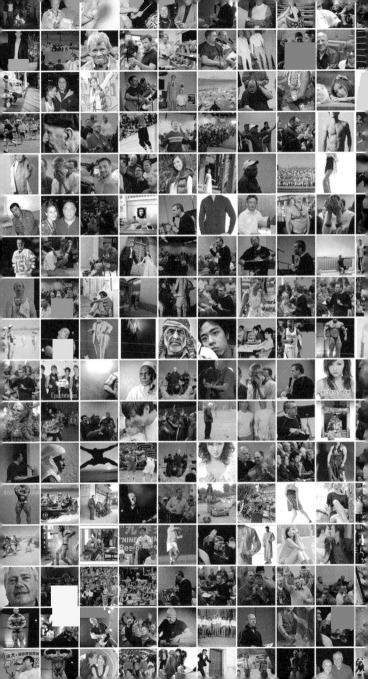

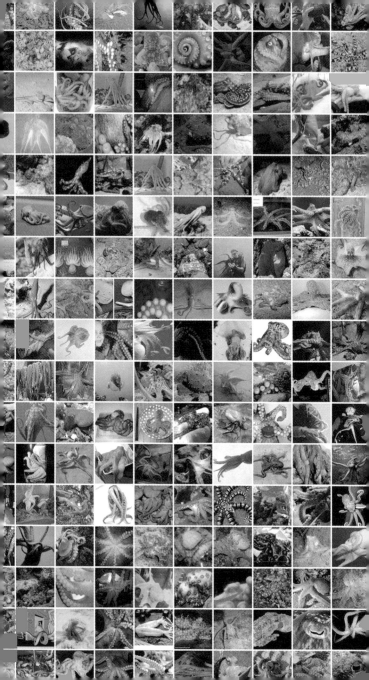

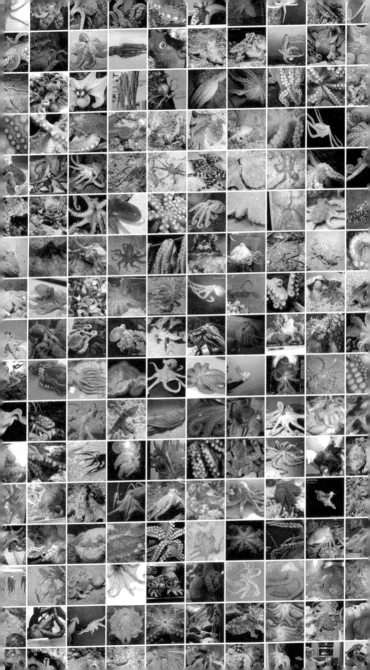

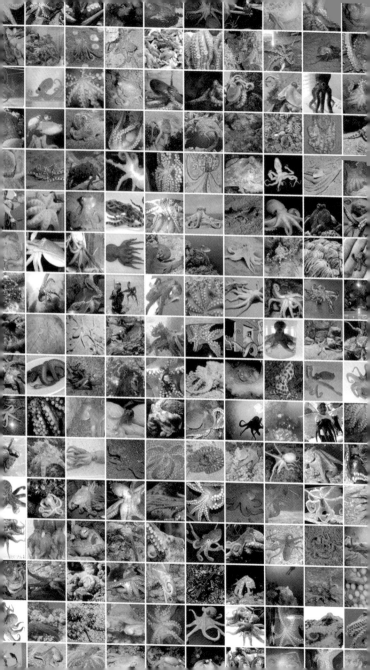

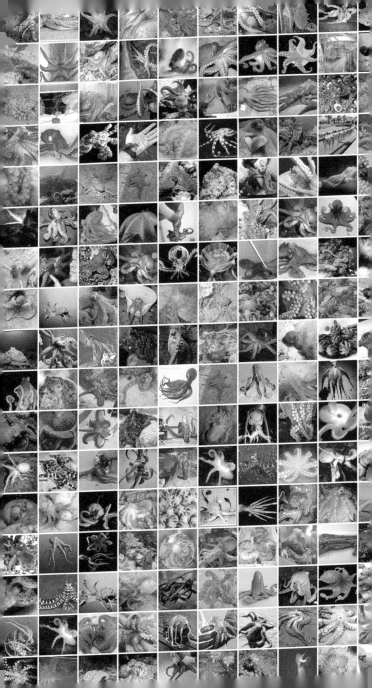

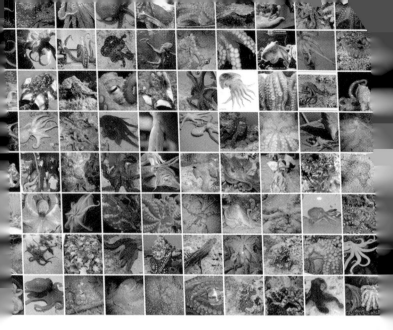

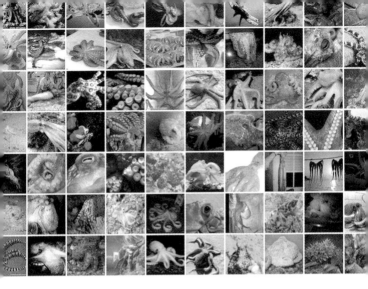

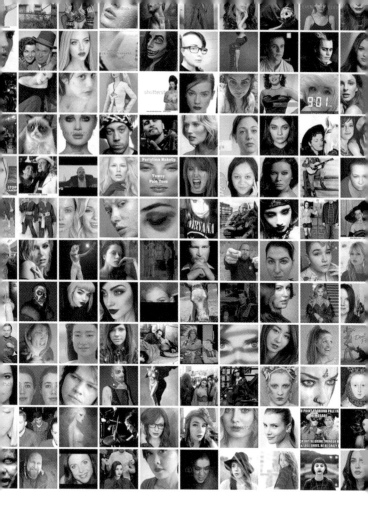

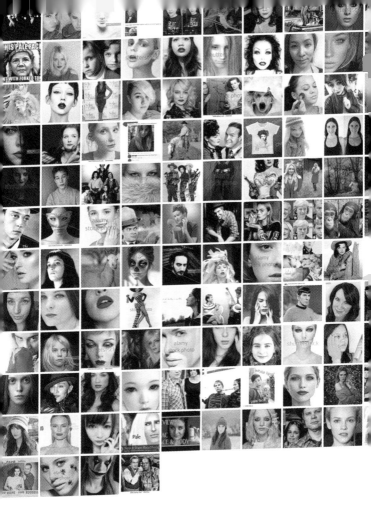

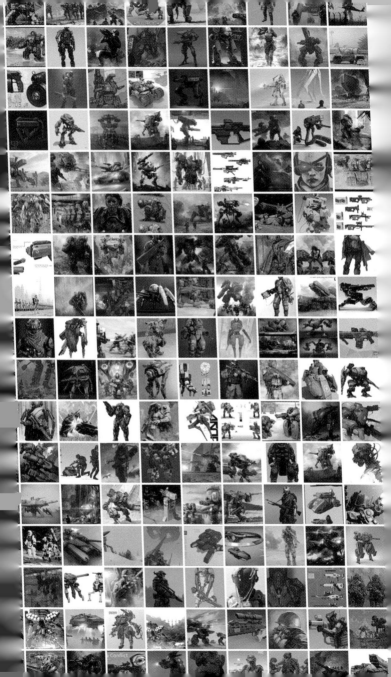

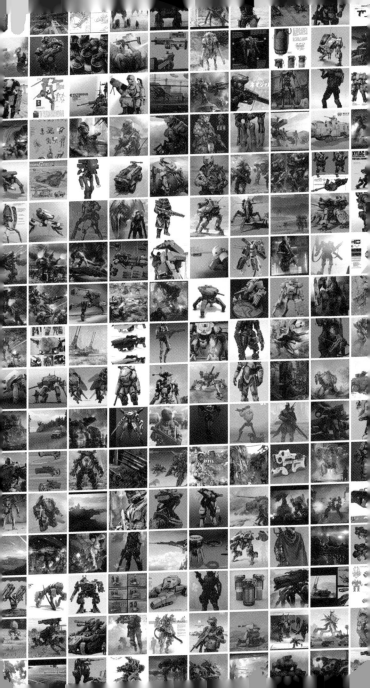

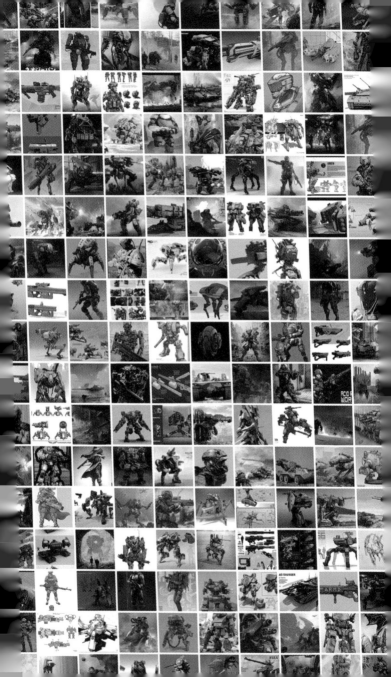

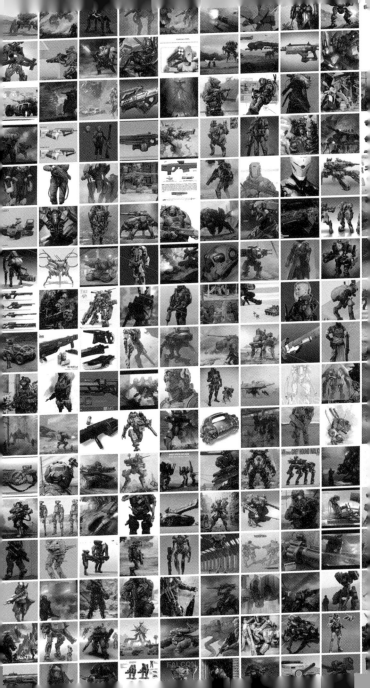

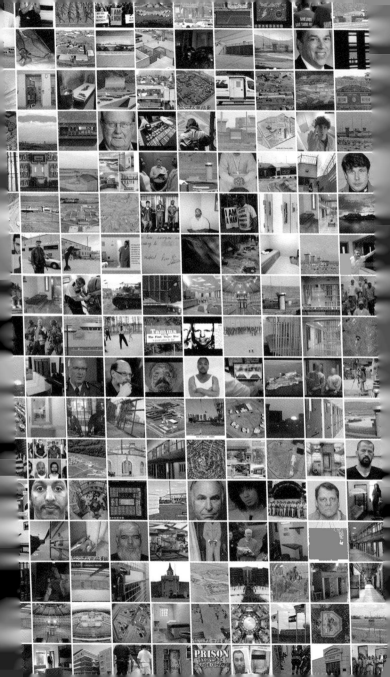

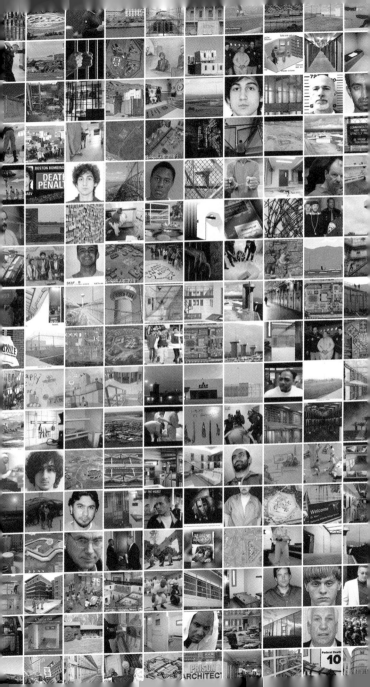

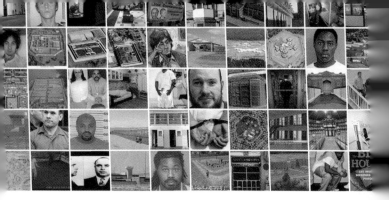

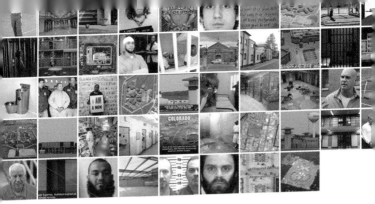

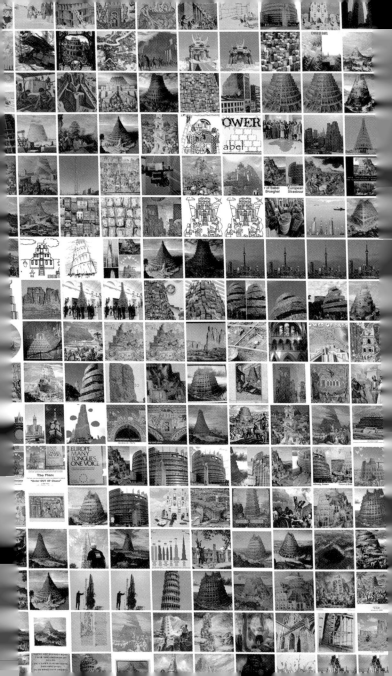

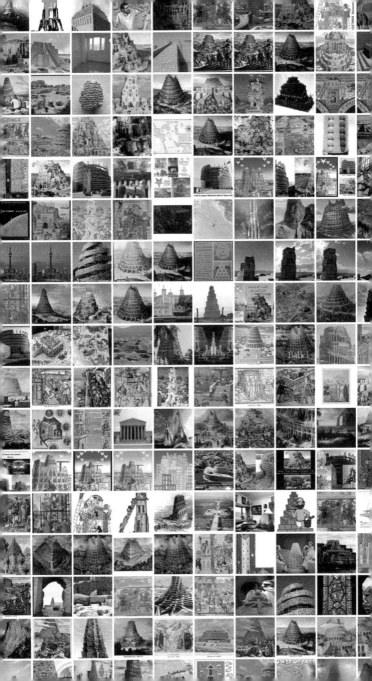

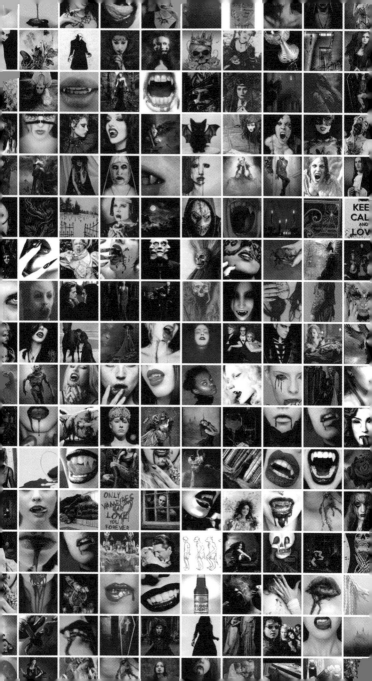

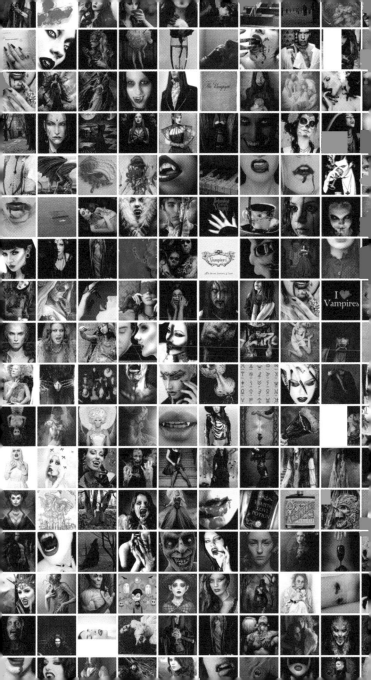

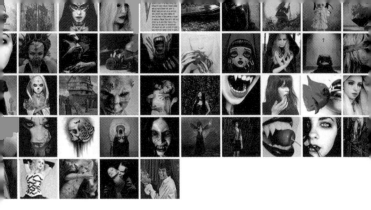

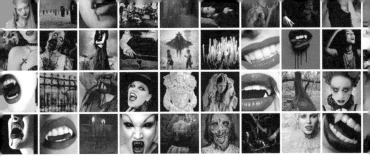

Influencing Machines

Trevor Paglen and Anthony Downey in Conversation

Anthony Downey I want to start with your work on artificial intelligence (AI) and how it relates to your broader research on neural networks and computer vision.

Trevor Paglen I started looking seriously at computer vision and AI in 2010 and 2011. It was difficult to get your hands on a lot of the tools at the time, so I worked with my studio assistants to build a homemade software platform for working with computer vision, which we called Chair.[1] We would assemble different pieces of code or algorithms—a lot of which had been published in the academic literature at the time—and incorporate them into Chair. Working from there, we could instruct the platform that we wanted to look at any picture or video through the "eyes" of a particular algorithm. For example, we could say to Chair, "I want to look at this picture of a cloud through the eyes of a computer-vision system similar to those found in a guided missile." This led to an exploration of how AI was producing models of seeing the world.

AD What are the difficulties involved in instructing an AI platform to see, which is to say identify and classify, images?

TP The initial aim was to experiment with object classification—to teach the system to recognize particular classes of images, say, oranges or bananas. It was around this time that I started to understand certain distinctions between classical algorithms and the newer machine learning algorithms. The older algorithms are more Euclidean, or geometric, for want of better words. They tend to discern edges, shapes, gradients, and then use those geometries as abstractions for objects that exist in the world. For example, you can think about a street as being

an abstraction of three lines—a line on the left, a line on the right, and a line down the middle. That is how, in broad terms, classical algorithms operate: they look for geometric correspondences among abstractions in order to classify images of objects (such as a street or a car or a building). However, with machine learning, and deep learning more generally, you take a really different approach: you use huge datasets and instruct the machine learning platform to perform statistical analyses on those datasets. The model can then, in theory, learn to distinguish among the various images in the dataset.[2]

I was particularly interested in the composition of these datasets and how you can modify and take advantage of the processes involved in their creation. You create a dataset by collecting a huge number of images of one thing, assigning labels (categories) to groupings of these images (for example, "orange" for pictures of oranges, "banana" for bananas, and so on), and then you use that as a training set to train a neural network to see images that it had not yet encountered. When you're building the image-classification model for a machine learning algorithm, it will analyze everything in those datasets, identify self-similar features among all the images in a particular category, and make other connections across all the images. These connections are not simply geometric, however, as is the case with more classical algorithms; they rely on many more parameters, including colors, shades, and shapes.

AD Can you give an example here?

TP If you decide to build a machine learning model to recognize the difference between a turtle, a banana, and the sun, you start by building a dataset—putting lots

of pictures of each of those objects into a collection that you'll use to train the model. When you do the training, the machine learning algorithms will analyze those images and look for what is self-similar in each object (what constitutes an image of a turtle, a banana, and the sun, for example). A turtle, as an image class, will most likely have an ellipse on the top of the shell; it might have some feet, possibly a tail; the color green might be dominant. For a banana the self-similar elements could relate to more yellow gradients, with occasional black spots; the overall shape could be defined by arcs. The sun, on the other hand, might be a luminous blob. Once you've trained your model to classify images, it will look at images it hasn't seen before and try to decide whether there are any turtles, bananas, or suns in the image. Is this new image more akin to a luminous blob, a series of arcs and yellow gradients, or an elliptical green shape? The algorithm tries to recognize things by looking for the features most associated with a given object that it has been trained on.

AD In your series Adversarially Evolved Hallucinations (2017–ongoing), there is a move towards encouraging viewers to not only reflect upon AI and its apparatuses but to think from within them—to think from *within* machine models of seeing.

TP When you work with neural networks, you realize that the training data (input) is the key element in the process of image classification, and this is a good starting point for figuring out what is happening inside the so-called black box technologies that constitute the machine learning approach. The Adversarially Evolved Hallucinations series is very much about what happens inside these processes, and how you excavate that and make it more explicit. When someone develops

datasets and training sets, for example, they are making assumptions about the relationship of images to objects, and that needs to be made more overt and unambiguous.

AD Can you expand on that: What do you mean by assumptions?

TP Creating a training set involves the categorization and classification, by human operators, of thousands of images. There is an assumption that those categories, alongside the images contained in them, correspond to things out there in the world. There are a few metaphysical assumptions here: First, that there is an uncomplicated correspondence between images and the things they represent out there in the world (i.e., that there's nothing complicated about taking a picture of a turtle and labelling the picture "turtle"). The second assumption is that the "world out there" can be neatly organized into a bunch of self-similar categories (turtles, bananas, clouds, etc.). What follows from the first two assumptions is that you can use quantitative approaches to interpret images (i.e., you can build an algorithm to "recognize" turtles). I refer to these assumptions as "machine realism."

The problem with machine realism is that very few people who think deeply about art or representational theory would take these assumptions seriously. They're incredibly reductive in terms of what they assume about images and what they assume about the "world out there." Images are far more complicated than this. It would be ridiculous, for example, to explain Velázquez's *Las Meninas* as "a group of people in a drawing room with a dog."

Generative Adversarial Networks

AD To create the Adversarially Evolved Hallucinations series, you began with various taxonomies—or, to use your terminology, corpuses—including OMENS AND PORTENTS, THE INTERPRETATION OF DREAMS, AMERICAN PREDATORS, and EYE MACHINE.[3] If I understand correctly, each of these corpuses is a dataset and in each of these datasets there are labelled categories of images. So, to take one example, the OMENS AND PORTENTS corpus/dataset contains the categories "rainbows," "comets," "eclipses," and "black cats."

TP Yes, that is the general gist of it—and each corpus can include more than one category of images.

AD So each individual dataset/taxonomy (or "corpus") produces the images we see in the Adversarially Evolved Hallucinations series. So, the OMENS AND PORTENTS dataset/corpus produces the final work *Rainbow*?

TP Yes, that's exactly the case: each dataset (corpus) produces a work in the overall series.

AD Given that the corpuses you produce seem intentionally abstract, rather than reductive or deterministic, they tend to be very allusive, if not elusive, concepts; they need a considerable amount of political, cultural, and historical context to fully understand their meaning. I suppose the question I am working towards is why they tend to be more speculative taxonomies/datasets, or corpuses, than the more reductive ones we associate with training AI systems?

TP The series is, in part, a critique of "machine realism," as I mentioned. In contrast to how computer-

vision systems work, humans have all sorts of weird taxonomies that we use to try to makes sense of the world: taxonomies for dreams, tarot cards, historical events, ideas about some things being "lucky" or "unlucky," and even taxonomies of allegories. Humans' relationships to images are very fuzzy and malleable. This is why I wanted to build datasets for the Adversarially Evolved Hallucinations series using taxonomies from literature, philosophy, art, and folklore. These corpuses/datasets were designed to perform an immanent critique of "machine realism," alongside the classical, more Linnaean taxonomies used in machine learning models.

AD Can you talk me through the process? How did you deploy these datasets/taxonomies to program an AI image processing model to *see*?

TP In practical terms, I began by collecting a lot of images from various sources, including the internet, magazines, and anywhere else that I could find an image that added to a specific corpus. I used search phrases for the type of image I wanted—for example "rainbow." You then have to "clean" the data and try to only select images that are good—that is, images that have rainbows in them. These images aligned with certain concepts or taxonomies that I had already predefined such as OMENS AND PORTENTS.

AD And a corpus, such as OMENS AND PORTENTS, is then used to train and generate an image-classifier model that can both recognize and generate as-yet-unseen images that *fit* into each corpus?

TP Yes, exactly. If you collate enough images in one corpus in order to train a neural network, you can produce an image classifier that can see things it

associates with, for example, omens and portents. Given that the categories included in the OMENS AND PORTENTS corpus included images grouped under the headings "comets" and "eclipses" and "black cats," the image classifier can produce images that resemble comets, eclipses, and so forth. In this instance the machine learning and computer-vision model is being trained on datasets that I labelled according to the taxonomies I chose. So, I made a computer-vision model that looks around and sees images associated with OMENS AND PORTENTS everywhere, and because the training set is limited to seeing only omens and portents, the model can see those and nothing else. It can only produce, or generate, images associated with the corpus OMENS AND PORTENTS.

AD Let's look more closely at the categories of images you were using. To take one example: the corpus AMERICAN PREDATORS had individual categories of images comprized of "Venus flytraps," "drones," "wolves," and "Mark Zuckerberg." One of the works that came out of the AMERICAN PREDATORS corpus is titled *Venus Flytrap*, but it is a somewhat askew image inasmuch as it has only a passing, somewhat uncanny resemblance to the plant in question.

TP Very much so, and that is precisely why I'm using the concept of hallucinations, which in AI parlance often describes things that a model might produce in error—images that are untethered from reality. Something similar happens in ChatGPT as well: it might give a footnote to a book that doesn't exist or "hallucinate" a fictitious answer to a given question.[4] I would suggest that every product of an AI system always exists on a scale of hallucination in the sense that the apparent correspondence between what a model is classifying

and how it relates its systems of classification to referents "out there in the world" is not only misleading but hallucinatory.

AD There seems to be an important distinction here between the deterministic function of machine vision in image recognition and the generative, perhaps more allusive function of the practices you have developed in Adversarially Evolved Hallucinations.

TP The training of neural networks is a stochastic, or random, process inasmuch as you could train a neural network on the same data multiple times and end up with different results.[5] This has to do with the weights and augmentations and so forth that were used in the process. However, facial-recognition technologies tend to present themselves as reliable. That is a big assumption, not only about the efficiencies of these technologies, which remains doubtful and prone to error (or hallucination), but also the supposition that the creation of a given training set will adequately and without fail identify future images. In facial-recognition technologies, this has serious implications when we consider false positives and how you redress—or even address—the errors of such apparently closed systems. One of the elements in Adversarially Evolved Hallucinations is to draw attention to this and highlight the less reliable elements involved in machine learning systems.

AD The datasets that comprize each corpus are trained through generative adversarial networks, or GANs, to produce artificial neural networks that are capable of recognizing a certain image. Can you talk through the technological aspect of this, the actual workings of a GAN system, and the broader implications of such technologies?

TP Generative adversarial networks use two neural networks that operate in a competition of sorts: one neural network is the "generator" and the other is called a "discriminator."[6] In simple terms, the generator can draw things and the discriminator can say what a drawing looks like. Let's take an example: for the individual corpus OMENS AND PORTENTS, I first trained the discriminator on image groupings (categories) that included "black cats," "comets," and other elements associated with prophecies. Once trained through a given dataset, the discriminator can distinguish between categories of images—it can distinguish an image of a black cat, for example, from a comet. Then I start the generator. At first, the generator creates "noise," or random image data that does not resemble anything at all. The generator starts sending completely random drawings to the discriminator, and the latter begins to evaluate how similar that "noise" is to the type of image it is looking for. The discriminator responds to the generator with a "confidence score." The goal of the generator is to create an image that generates a high confidence score from the discriminator. Based on this feedback loop, the generator will revise the initial image and send a new one back to the discriminator, receive more feedback, then reweigh the generative process until the confidence score improves. This back-and-forth goes on until the generator is able to make images that the discriminator believes are examples of the type of image it is looking for. The discriminator, in short, coaches the generator to create an image that looks more and more like the assignment. I am simplifying here for the sake of illustration, but that is the gist of it—the discriminator and generator go back and forth until they reach some degree of agreement on an image.

AD Hence the term "adversarial"?

TP Yes, this is the adversarial process: the generator produces images until the discriminator accepts them as looking adequately similar to the type of image it's looking for. This is a very streamlined account of a highly complex mathematical process, but suffice to say the generator will eventually produce a synthetic instance of one of the objects (images) described in the model.

AD So, in effect, the original dataset, which consists of image categories such as "black cats," "comets," "rainbows," and so on, are the starting points for training the discriminator neural network in the GAN?

TP Yes, precisely, but the interesting element here is that through training the discriminator and the generator neural networks to be an effective image-classification system, via the architecture of a GAN, they can nevertheless only recognize instances of the objects (images) they have been trained on. Say you train a neural network to recognize the difference between a comet and a cat, then that's the only thing the model can classify. If you hook that model up to a webcam and show it a picture of a plate and it might say, "Well, this looks more like a comet than a cat because it has some kind of ellipses and it has more gradients, so it is a comet." You could then show it a picture of a keyboard and it might say, "This looks more like a black cat than a comet, since it's black and white and has stripes," and so on. The model will give each classification a specific assignment that is roughly to do with whether the designation has been made with a high or low confidence score, and the system will operate according to such scores.

AD And then the generator will, based on the feedback of a low-confidence designation, for example,

synthesize more images to "match" what it deduces—through the process of looped feedback—the discriminator is looking for?

TP The generator will basically begin to "evolve" in the direction that the discriminator guides it in over time, hence the term "adversarial *evolved* hallucination."

AD You mentioned that there are stages in this process and used the term "primitives," which are images, or parts of images, that reside in the latent space of machine learning systems. Could you explain what they are exactly and where they fit into this adversarial process?

TP When you're training a discriminator, you are basically feeding it a thousand pictures of a black cat or a comet or a banana, and the training process will break each of those images down to component parts. For example, a banana is likely to have two arcs ranging from the top to the bottom of the fruit; it could have yellow color gradients, some brown spots, a stem at the bottom, and so on. These subcomponents effectively constitute the "latent" space of the model. To classify an image, the model will look for specific patterns of these primitives. This explains, in part, how we are able to take complex images, break them down, and quantify them for image-classification systems and machine learning more broadly. The image-classification system (discriminator) would be looking out for these subcomponents while the generator, through applied weights and various iterations of data, would be training its system to better produce them over time.

AD These primitive stages of the image would be like sketches or sections of the final image, perhaps?

TP I think about each of the primitives as being akin to a pencil- or brushstroke. A specific pattern of pencil strokes makes a face, a different pattern makes a banana. It took me a while to wrap my head around this: the process is very similar to how you learn to draw. You learn your basic "primitive" or generic shapes. You draw a circle, an ellipse, a triangle, a square, and so on, and then you conjoin them into more complex objects and images. These are the basic building blocks of drawing. As you evolve as an artist, you tend to forget that this was how you thought about images, but it is also how neural networks operate while they are being trained: the generation of primitives, where an image is broken down into its component parts, will be used as the basis for assembling more and more complicated images in a machine learning system. And these primitives reside in what we might call the latent space of the classification model. Again, I am translating a highly complex mathematical process into everyday language, but that's the general substance of the process.

AD How complex does it get?

TP The latent space of the model contains all the arcs, gradients, lines, colors, shapes, and other components, but the primitives can be much more complex than that—certainly more complex than the shapes that you might learn in a drawing seminar. As you move through the latent space of that model, they become even more complex. In our Chair AI platform, I can task the GAN with making a synthetic image of a place in the latent space of the model. For example, I can propose something like, "Instead of generating an image of a cat, generate an image of neuron 7382," or any other place (neuron) in the latent space. The

generator then evolves an image in the direction of criteria dictated by the specificities of what is in the latent space.

AD This returns us to my opening question, albeit with a twist: How can we move away from reflecting upon the operative logic of AI as a "black box" system— an apparatus that is often presented as opaque—and towards a method of thinking from *within it*, if not disrupting its apparatuses?

TP In part that is what I am doing, but I should also note that this is only really possible with simple models (and remember that the work we're talking about here was done in the 2010s and came out in 2016 and 2017, which is Palaeolithic in machine learning time). When you start to look at later generative models, like ChatGPT or Midjourney, it is far more difficult (and expensive) to look inside them. I'm not sure the kind of work I was able to do on our studio computers in the 2010s would be possible on newer models without a well-funded lab with a lot of computing resources.[7]

Uncanny Technologies

AD I was thinking earlier of Freud's *The Interpretation of Dreams*, which was first published in 1900, and how that volume relates to his 1919 essay on the uncanny.[8] Throughout *The Interpretation of Dreams* there are multiple examples of how the "work" of dreams resembles uncanny or unsettling features related to vision, or visions. I have always understood the uncanny, in this sense, to be a primarily visual phenomenon—an ocular discombobulation of sorts, or an apparition, that disrupts reality and our perception

of it. It is about disturbing a frame of reference, or appropriating and inhabiting a given reality. Although AI sees or constructs a reality that is invariably presented as definitive or authoritative, the presence of the uncanny image, in these contexts, would appear to have the potential to subvert such definitiveness or computational certainty.

TP AI systems, be they recommendation algorithms or generative AI models, actively perform processes of manipulation: they *want* you to see something. So, yes, it is about machinic perceptions of reality and how we can disrupt them through alternative models of visualization. We could mention here recommendation algorithms or AI more generally: they are basically influencing machines, and they achieve influence through the extraction of value and the use of classification systems to define certain features of the world we live in. This is also where hallucinations come in: these influencing machines generate hallucinations, uncanny ways of seeing, that make you see something in a particular way or believe something in a particular way. These processes have a military history in the field of psychological operations, or psyops, where military operatives construct realities for an adversary in order to convince them that the world exists and behaves in a particular way. I have been thinking about this process— the notion of how machines operate upon or *influence* the world—with a number of works that I'm currently working on. These works use the framework of psyops to consider how reality is perceived, or how realities are *influenced* by various structures of ways of looking at the world, including those defined by political or governmental pressures and demands.[9] Psyops is about influencing the realm of perception; it is the strategic or tactical release of information designed

to make people see things that you want them to see, whether they exist or not. If you can make people perceive something, you can make them believe it, but to do that effectively you need to exploit certain features or aspects of human perception or common belief systems. The emotional life and group dynamics of people and communities can become the entry point for effectively altering their psychological attitudes towards the world. And AI is increasingly playing a significant role in this process.

AD I recently recalled, when thinking about Adversarially Evolved Hallucinations, a quote from Sol LeWitt's 1967 short essay "Paragraphs on Conceptual Art," which picks up on some of the crossovers between creative and mechanistic forms of production. LeWitt wrote: "The idea becomes the machine that makes the art."[10] In part, this picks up on a dichotomy of sorts between thought and computation, or the relationship between the probabilistic idea and the deterministic machine. In many ways it goes to the ontological question of what it is to create: What is the metaphysical or elusive context of creation that you cannot create through a mathematical calculus or with an algorithm?

TP I think that would be a good place to start to try to untangle the dichotomies between human thinking and machine computation, or creativity and the models of statistical analysis that algorithms perform. Thinking about Adversarially Evolved Hallucinations and my more recent work on psyops, it seems the connection lies in how we are striving to get a clearer understanding of what types of "worlds" machine learning is creating. Revealing the systems that produce images or classify them has two functions: One is about demystification.

It is difficult to understand intuitively how a statistical engine, or an algorithm, could generate an image that you as a human experience as something that has an inherent meaning and an affinity to your world. This has to do with an implied intentionality, inasmuch as historically it was humans who created images, and there is therefore a tendency to assume that when we see an image it is the product of a thinking, speaking being who exists in the world, even if it is actually a machine learning system that produced the image. Our intuition about creativity cannot fully account for that, so we attribute some kind of supernatural element to the machine. We assume that an machinic image makes sense or that it has meaning. We also assume that the machine must have some level of intentionality, in the way a human might, when it presents us with an image of the world; because we cannot fully explain what's going on, it must be "intelligent." But when you examine the anatomy of how training sets are constructed, you can see the ways in which political and sociocultural assumptions are built into them, and how models of seeing and perceiving the world have become influencing machines, designed to affect and inform our perception of the world and normalize the computational activities involved in that process.

AD There's been a lot of debate recently about how large language models (LLMs) in generative AI are now influencing how we see the world, but this discussion is also about how models, such as ChatGPT and other forms of machine "creativity," are threatening human creativity. You seem to be taking a more nuanced approach to this inasmuch as you are saying AI is not about threatening creativity per se, but realigning, or recalibrating, what we understand the ideal of creativity to be.

TP I bristle a little with the concept of creativity; to me it has a lot of supernatural baggage. I think we have an intuitive understanding of the concept of creativity as being something that comes from somewhere else, something undifferentiated and otherworldly that exists on an imaginative plane. When you look at the fields of cultural production that are now most threatened by AI, they are the ones that have become the most routinized or templated. When you look at things like blockbuster-film screenwriting, comic graphics, or stock photography, these are highly refined if not rigid genres, which is why AI models seem to have such an easy time reproducing them.

Machinic Ontologies

AD There is a corpus titled EYE MACHINE, which produced the works *A Prison Without Guards* and *A War Without Soldiers*, and I recognize a direct reference here to Harun Farocki's trilogy *Eye/Machine* (2001–3). When we think about Farocki, and you have written about his practice elsewhere (specifically his work on machine vision and "operational images"), I always think about the role of war in these processes— how image regimes, or machinic ontologies of vision, increasingly define our perception of the world.[11]

TP In media theory, the first Gulf War was a watershed moment in the sense that it is understood as the first war that takes advantage of "smart" weapon systems—weapons that used precision guidance, computer vision, autonomous models of navigation, GPS, and so-called stealth technologies. For Farocki and others, such as Paul Virilio, that war represented a new relationship between images and warfare. It

also inaugurated new models of image functionality; images became parts of technical systems—embedded in guidance processes and missile-targeting procedures—and those developments are encased in a black-box logic of image production.

AD I want to focus on this for a moment, as it brings us back to the beginning of our conversation, but also raises a further question: How are we being ontologically positioned, if not produced, through and in relation to machinic models of perception? We increasingly appear to inhabit new paradigms of being-in-the-world or subject positions that are being produced *through* the operations of AI systems but, as you observe, these vistas or visions—or hallucinations—are automatically created from models of data extraction and the algorithmic rationalization of data. As machines evolve, our understanding of subjecthood—what it is to be— is evolving too.

TP Do you mean the shift from a what we might call a kind of surveillance or control paradigm of technology towards a generative paradigm of technology—how that affects or produces subjectivity?

AD Yes, I suppose I am drawing here on the Foucauldian notion of disciplinary power: power that evolves according to a given epoch, or era, so that the conventional model of discipline—i.e., control visited upon the body through torture or physical coercion— transforms into a different model of disciplinary control whereby the body, or subject, is rendered "productive" through various technologies, including surveillance. The productive subject, the subject of modernity, can thereafter perform, or conform to, the political and cultural imperatives of a particular era, say neoliberalism,

and become established—or positioned—through the apparatuses of statehood or governance. It seems that AI, in our time, has become precisely such an apparatus: it induces the modern subject to perform in a certain way. The techno-politics of machinic vision encourages or induces the subject to perceive reality in a certain way, and to therefore behave accordingly, for want of a better phrase.

TP I think that's exactly it, especially if we consider how contemporary models of disciplinary power are embedded in, say, facial recognition or credit scores, and how that is directed towards the modulation of everyday life based on certain classifications related to consumerism and capital. When I think about the shift towards contemporary notions of discipline, implied in data extraction and applied computation knowledge, and towards the more "productive" turn in AI (how it is increasingly geared towards guiding or influencing decisions or realities), it seems it is designed to efficiently manipulate the subject towards specific ends. This could be getting you to buy something or, more and more, ensuring that you perceive reality in one specific way rather than another. In this sense, it could be about influencing your politics, your biases, your world outlook and allegiances. We do seem to be morphing towards a new turn in AI technologies and, going back to the idea of psyops, that seems to reside in a shift from the idea of the internet as a model of surveillance towards an internet as means to manipulate its users in the direction of certain ends.

AD Machinic visions, it seems, are increasingly becoming *our* vision, or perception of the world. I was thinking here of your 2019 project *From "Apple" to "Anomaly" (Pictures and Labels)*, specifically the focus

in that work on how AI networks are taught how to see the world through datasets that perpetuate racist, sexist, and homophobic categories, as well as other models of discriminatory bias.[12]

TP There are direct connections here between that body of work and Adversarially Evolved Hallucinations, for sure, especially around the normative realms of seeing that machine vision incorporates and replicates. Arguably, Adversarially Evolved Hallucinations and *From "Apple" to "Anomaly"* explore how the creation of AI models is very much a reality-building exercise.

AD I am wondering here about how calculations of reality impact our political affiliations, and how we understand the politics of activism more broadly. When we think about how algorithms amplify or generate algorithmically defined models of perceiving and engaging with realities, it is as if there is an increasingly ubiquitous algorithmic "command"—both overt and, indeed, covert—that produces reactions to certain political issues, but we still lack the literacy to push back against such techniques or navigate our way through their habitually opaque machinations.

TP I've been thinking a lot about what media literacy would look like in an age of generative AI, and how we need to understand the mechanics of something—be it the "black box" of AI, or the assumptions we make about images in the world. In terms of Adversarially Evolved Hallucinations, I wanted to be able to explain exactly how the images were made and to call attention to the relationship between the datasets and the final images—the relationship between categories such as "comets" and the work *Comet*. I wanted to do this in order to demystify AI as a model of image production.

But I also wanted to show how the range of possible things that can be conceptualized, for lack of a better word, by a neural network—or by a generative AI model—is constrained. A model can only produce a version of the world based on its dataset, and it is restricted in that vision of the world by the limits of the dataset it is trained on. That is not to say that generative AI won't have a big impact on culture, because I think it's pretty self-evident that it will.

1 The software was referred to as Chair because, in order to operate it, users had to sit in what resembled a captain's chair—the designation stuck and became the overall name for the AI platform.

2 Machine learning and deep learning are often understood to be subsets of AI. Machine learning is an approach that tends to focus on the use of algorithms to "teach" computers to learn from input data. As a technology it learns from input data—datasets of images, for example—in order to make decisions or predictions about future image classifications. The end goal of machine learning is that it will recognize patterns in the input data, eventually make sense of information and "recognize" images that it has yet to encounter. Deep learning is similar, inasmuch as it a type of machine learning. Like machine learning, deep learning uses artificial neural networks (ANNs) to "learn" and to make decisions in manner that is often considered to be similar to the way human brains work.

3 There are thirteen corpuses in total, including OMENS AND PORTENTS; THE INTERPRETATION OF DREAMS; AMERICAN PREDATORS; EYE MACHINE; THE AFTERMATH OF THE FIRST SMART WAR; MONSTERS OF CAPITALISM; THE HUMANS; THINGS THAT EXIST NEGATIVELY; FROM THE DEPTHS; KNIGHT, DEATH, AND THE DEVIL; SPHERES OF HEAVEN; SPHERES OF PURGATORY; and SPHERES OF HELL. The term "corpus" is used by Paglen to define an individual taxonomy/dataset.

4 Such errors, or hallucinations, can be costly. Bard, Google's rival to Microsoft's ChatGPT, incorrectly answered a question about the James Webb telescope in February 2023. This error, or hallucination, saw the share price of its parent company (Alphabet) drop by $100 billion overnight. See

Natalie Sherman, "Google's Bard AI Bot Mistake Wipes $100bn Off Shares," *BBC*, February 8, 2023, https://www .bbc.co.uk/news/business-64576225#.

5 Used to define a random sequencing of events, a stochastic process defines the unpredictable evolution of a given event over time. Weather patterns and stock markets are both subject to fluctuations based on numerous factors that render their evolution probabilistic, rather than deterministic, over time. We should note here that AI systems often employ stochastic variables in the algorithms used to train neural networks. A stochastic gradient descent (SGD), for example, is a model used in machine learning to find the best solution by performing steps in random directions—over multiple epochs or iterations—to attain the best possible answer, classification, or prediction (output). These outputs generalize multiple results and then, based on statistical analysis, choose the most likely one.

6 See Ian J. Goodfellow at al., "Generative Adversarial Networks," *Communications of the ACM* 11, vol. 63 (November 2020): 139–44, https://doi .org/10.1145/3422622.

7 Midjourney is a generative-AI program. It produces images from natural language descriptions ("prompts"), and was launched in 2022.

8 Throughout his later essay "The Uncanny" (1919), Freud explores the multiple meanings of the term *Unheimlich* (the "unhomely") and its reification as a material or visual object that perturbs the viewer and questions perceptions of everyday objects and events. See Sigmund Freud, "The Uncanny," in *Art and Literature*, vol. 14, The Pelican Freud Library (London: Penguin Books, 1988), 335–76. See also, Sigmund Freud, *The Interpretation of Dreams*, trans. James Strachey (London: George Allen and Unwin, 1964).

9 *Psyops* refers to "psychological operations," which involve the dissemination of information to individuals and groups that is designed to influence their subsequent motives in relation to, and understanding of, events. This can begin with the objective reasoning of people and communities, but it can also be designed to impact and manipulate governments and other larger-scale organizations. See Trevor Paglen, "You've Just Been Fucked by PSYOPS," https://paglen.studio/PSYOPS/

10 Sol LeWitt, "Paragraphs on Conceptual Art," *Artforum*, June, 1967.

11 Trevor Paglen, "Operational Images," *e-flux Journal* 59 (November 2014), https://www.e-flux.com /journal/59/61130/operational-images. See also: Anthony Downey, *Neocolonial Visions: Algorithmic Violence and Unmanned Aerial Systems*, PostScript[UM] 47 (Ljubliana: Aksioma, 2023), https:// aksioma.org/neocolonial-visions -algorithmic-violence-and-unmanned -aerial-systems.

12 See Kate Crawford and Trevor Paglen, "Excavating AI: The Politics of Training Sets for Machine Learning," September 19, 2019, https://excavating .ai. See also Kate Crawford, *The Atlas Of AI: Power, Politics, and the Planetary Costs of Artificial Intelligence* (New Haven: Yale University Press, 2021).

Images: Primitives

Primitives is a term given to the parts of images that reside in the latent space of machine learning systems. When a neural network is analyzing an image, it breaks the image down into its subcomponent, or "primitive," parts. The subcomponents of a banana, for example, could consist of two arcs, yellow color gradients, some brown spots, a stem, and so on. These constitute, in turn, the latent, evolving space of the model. Paglen likens these primitives to pencil marks or brushstrokes insofar as each of them represents a basic shape or line that could constitute a bigger picture.

The primitives included on the following pages are for the purpose of illustrating the multidimensional and latent space of GANs, and are therefore not intended to be viewed as finished works.

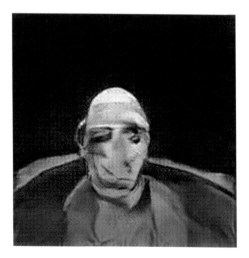

Research/Practice: Trevor Paglen

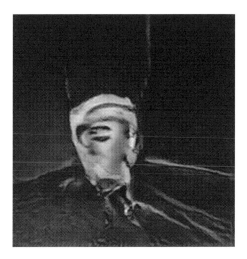

Images: Primitives

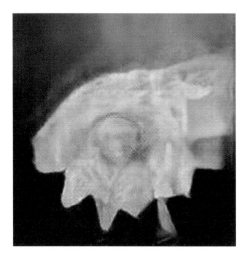

Research/Practice: Trevor Paglen

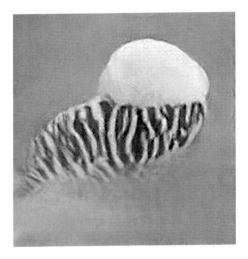

Images: Primitives

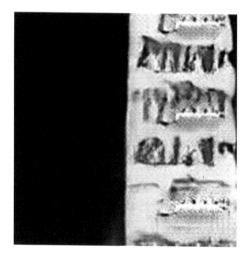

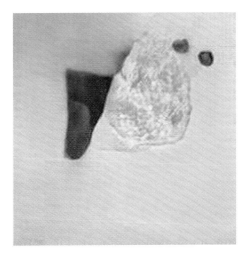

Images: Primitives

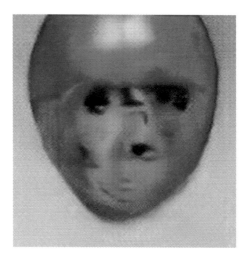

Research/Practice: Trevor Paglen

Images: Primitives

Research/Practice: Trevor Paglen

Images: Primitives

Research/Practice: Trevor Paglen

Images: Primitives

Research/Practice: Trevor Paglen

Images: Primitives

Research/Practice: Trevor Paglen

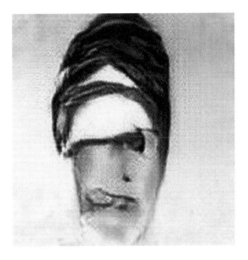

Images: Primitives

Acknowledgments

Claudia Altman-Siegel
Lidiya Anastasova
Laura Attanasio
Stuart Bertolotti-Bailey
Renee Brown
Allison Card
Margherita Ciocci
Tamara Corm
Wayne Daly
Fairfax Dorn
Danielle Forest
Arne Glimcher
Marc Glimcher
Annelie Graf
Hanna Mattes
Eilis McDonald
Ryan Muller
Daniel Costa Neves
Caroline Schneider
Daelyn Short Farnham
Margot O'Sullivan
Samanthe Rubell
Leif Ryge
Anna Thausing
Valentina Volchkova
Raphael Wolf

Contributors

Trevor Paglen is a multidisciplinary artist known for blending image-making, sculpture, journalism, and engineering into his work. His art, which explores themes such as state secrecy and artificial intelligence, has been exhibited globally, including at the Smithsonian Museum of American Art and the Barbican Centre. Notably, Paglen launched an artwork into orbit and contributed to the Oscar-winning film *Citizenfour*. He has also created public art for Fukushima's exclusion zone. An acclaimed author, Paglen's contributions to investigative journalism and art have been recognized with awards like the Electronic Frontier Foundation's Pioneer Award and the MacArthur Fellowship. He holds degrees from UC Berkeley and the Art Institute of Chicago, underscoring his diverse expertise across art, geography, and technology.

Anthony Downey is Professor of Visual Culture in the Middle East and North Africa (Birmingham City University) and the series editor for Research/Practice (2019–ongoing). He sits on the editorial boards of *Third Text*, *Digital War*, and *Memory, Mind & Media*. Recent and forthcoming publications include *Decolonising Vision: Algorithmic Anxieties and the Future of Warfare* (2025), *Falling Forward: Khalil Rabah—Works, 1995–2025* (2023), and *Shona Illingworth: Topologies of Air* (2022). Downey is the recipient of a series of Arts and Humanities Research Council (AHRC) awards, including one for a four-year multidisciplinary project that focuses on cultural practice and educational provision for children with disabilities in Lebanon, the Occupied Palestinian Territories, and Jordan (2021–25).

Research/Practice
Edited by Anthony Downey

Research/Practice 04

Trevor Paglen
Adversarially Evolved Hallucinations

Published by Sternberg Press

Editor: Anthony Downey
Managing Editor: Raphael Wolf
Proofreading: Stuart Bertolotti-Bailey
Design: Daly & Lyon
Printing: Tallinn Book Printers, Estonia

ISBN 978-3-95679-583-1

Distributed by The MIT Press, Art Data,
Les presses du réel, and Idea Books

Sternberg Press
71–75 Shelton Street
London WC2H 9JQ
United Kingdom
www.sternberg-press.com